Remembering
North Carolina
Tobacco

Remembering
North Carolina
Tobacco

BILLY YEARGIN

THE
History
PRESS

Published by The History Press
Charleston, SC 29403
www.historypress.net

Front Cover: There was a time when folks had better things to do than just sitting around in a comfortable reclining chair clicking remote buttons. In that "once upon a time" era, tobacco farmers took great pleasure and pride in showing off their tobacco-producing talents. The proof is illustrated on our front cover. This picture, taken in the summer of 1942, exemplifies all the pride that comes with curing a good barn of tobacco. As sister Betsy holds the horse, named "Nellie," and a handsome little four-year-old future farmer looks on, Tom Hobgood, a Granville County tobacco farmer, presents one of the finer sticks of newly cured tobacco.

Back Cover: For almost a half century Tom Johnson of the *Oxford Public Ledger* featured local interests in a section entitled "The Town Pump." On our back cover, a picture taken in September 1939 on the Ivey Day Farm in the Salem Township of Granville County focuses on a proud farmer and his mule, with a tobacco slide full of leaves, headed to the barnyard for "stringing, heisting and curing."

All photographs courtesy of the author unless otherwise noted.

First published 2008
Second printing 2011
Third printing 2012
Fourth printing 2013

Manufactured in the United States

ISBN 978.1.59629.433.2

Library of Congress Cataloging-in-Publication Data

Yeargin, Billy.
Remembering North Carolina tobacco / Billy Yeargin.
p. cm.
ISBN 978-1-59629-433-2
1. Tobacco--North Carolina--Anecdotes. 2. Tobacco farms--North Carolina--Anecdotes. 3. Farm life--North Carolina--Anecdotes. 4. Yeargin, Billy. I. Title.
SB273.Y44 2008
633.7'109756--dc22
[B]
2007051918

Thank you to Sondra Reed for being my friend at a critical time in my life. I truly admire your intense energy and marvelous creativity! But, far more than anything else, it has been your driving enthusiasm that has shone brightly upon me. Your expertise in this project has truly helped to make it one of the most exciting and rewarding endeavors of my life.

Contents

Introduction

Since Jamestown's most famous entrepreneur, John Rolfe, first gambled on the market value of tobacco in 1612, Americans have enjoyed a love-hate relationship with this wicked weed.

Long before Rolfe's marketing venture with British merchants, King James launched his distaste for what he termed the "foul" weed. His opinion was cited in the 1604 issue of his famous *A Counterblaste to Tobacco*, wherein he referred to tobacco as "Harmful to the Lungs and Hateful to the Nose." He then proceeded to levy a steep tax on the "weed" that underwrote his lewd, lascivious and boisterous lifestyle, which lasted far beyond his ability to enjoy it.

From Rolfe's first commercial venture, and lasting until the French and Indian War of 1763, America was the very definition of a tobacco society. Our tax obligations to the Crown were paid in pounds of tobacco. Wives were purchased and preachers were paid with pounds of tobacco. Tobacco was the currency that paid all the bills.

Seven of our first nine presidents were tobacco farmers, Washington and Jefferson being the most revered. Patrick Henry, the great "Liberty or Death" orator, rose to fame from litigation involving a preacher and his "tobacco" salary.

All of those facts are important. More important, though, is tobacco's "ground-level" influence on those of us who grew up on the mid-Atlantic tobacco farms of the greatest country on earth. We proudly proclaim our tobacco heritage.

Every story is different; yet every story is the same.

As a child, awakening every morning to both the smell and view of tobacco in some stage of preparation, growth, harvest or curing, I was surrounded by all the appurtenances of a tobacco dominion. I got sick and tired of it in a hurry.

Probably no one on the face of the earth ever hated tobacco farming as much as I did. Probably no one on the face of the earth loved it as much as my daddy. At the time, I just couldn't understand why he loved it so much. I thought maybe he had met with some mind-altering disease in his early life that left him with a severely warped sense of values and choices of how to make a decent living.

From the time of the first planting in early May until the last tips were pulled in September or October, Daddy simply could not stay out of the tobacco field. During working hours he walked up and down and across the rows, directing the business of plowing, hoeing, topping, suckering and priming, all with a scowl on his face. Really, his face was not that of a happy man. Mama used to say that he would "twist his face around when he got mad." So I guess he stayed mad a lot in the tobacco field.

Yet, on Sunday afternoon, or any time when company came, he strutted like a proud papa as he hosted the visitors out to the fields. "Notice how even these stalks are," he would say. "We spent a lot of time getting all the weeds out, but it looks a whole lot better than some other folks' tobacco I've seen. Reckon we'll have to git started on these ground primings next Monday. This stuff'll run away with you in a hurry if'n you don't keep up with them leaves yallowing."

"I believe this here is gonna be the best crop I've had since just after the war," I once heard him say to Mr. Kennon Taylor, president of the Oxford National Bank. In retrospect, I realize that he was setting the stage for borrowing money for that year's labor expenses.

Whatever personal differences or likenesses have arisen among tobacco farmers, one thing has been forevermore etched in stone: fraternal bonding and pride. Pride in tobacco; pride in the warmth that comes in nurturing tobacco from the planting to the warehouse; pride in the character built by the process, in the process and from the process. Process was not just a conscious issue—there was the subconscious issue of husbandry and identity. Much more so, though, tobacco farming was an issue of ancestral "roots," of cultural continuity.

Both sides of my family were products of the American tobacco culture. My maternal family came from the Murray, Noblin and Mangum tobacco kingdoms of nineteenth-century Southside Virginia and the Piedmont hills of upper Durham County and lower Person County, both of which are sandwiched in between Durham and Danville, Virginia. On the paternal side came the proud Adcocks (of Dutchville Wrapper fame) and Averettes of lower Granville County, as well as the Wake and Orange County

Yeargins. Among the preachers, educators and storekeepers there were a couple of horse thieves, but all were the children of tobacco and all were proud of who they were.

The recollections and stories born of life on a tobacco farm bring great pride to me. It is where I came from. And it commands a tough hide and a tender heart. I thank God for choosing the unique environment He did for me, all woven together around some element of an American tobacco culture. That culture shadows me at every turn in the road.

As you close the pages of this book, it is my sincere hope that somewhere inside you will have read a passage or seen a picture of yourself, if not in fact, at least in memory. If so, please feel free to add your own caption.

Tobacco Farming:

I Hated It! But, After All, I Loved It

When I was a child, I hated the sight of long tobacco rows. (The expression "gittin' in the short rows" was coined in a tobacco field.) I hated hearing the voice of my daddy, at six o'clock in the morning, saying, "Hurry up and eat your breakfast, son, they're waiting for you to go to the field." Or at 4:00 a.m., "Come on, now, we got to take out a barn of tobacco 'fore we can get started." I hated it when he would interrupt our Sunday afternoon neighborhood baseball game and coerce the whole team (to my embarrassment) to help round up stray cows that had gotten out because of falling-down fences, or to herd the mules into their respective stalls in preparation for the week's worth of "priming" tobacco.

I hated it when, under the policing eye of my daddy, I had to, as they say, "Stick my butt up to the sun" and pull the first round of ground primings. I hated it when the other primers, thirty feet ahead, yelled back, "Git up heah with us, we tired of keeping you up!" Or, with their sleazy tobacco-field philosophy, "Come on, now Boogie Woogie, it's hard, but it's fair." I hated it when six o'clock came on Friday night, my dating night, and there were two barns of tobacco, laying in two rows at the barn entrance, to be "heisted" before I could make a beeline to the house, take my washpan (bathrooms inside the house were a silly waste of money) bath and head out to the skating rink in Henderson where Martha Wade, the first love of my life, was waiting.

More than anything else, I hated it when all my buddies from school spent their afternoons hanging around the drugstore and bonding with the girls. I, on the other hand, had to go home and "pull off" tobacco in the strip house or, when the year's crop was stripped and ready to go

to town, I had to go to Banner Warehouse and help sweep the floors or unload the tobacco brought in by farmers from all over the Middle Tobacco Belt. No matter what I was doing, I had to be somewhere within earshot of Daddy so he could yell out something else for me to do. I remember many times, early in the morning on the farm, he would give me three day's worth of work to do and tell me to have it done before dinnertime. Then he would say, "If you git through with that before I git back, just find a tobacco stick and beat on a tree 'til I git back." I hated it!

But today, more than a half century later, I have a different view. A different view perhaps because of the phenomenal impacts those tobacco fields and warehouses have had on American society. Or maybe it is a product of the drastic departure from my adolescent view of hot and hard work into a transitional one of assessing who I was then and how it impacts me now.

What do those tobacco fields represent? They represent all the elements of my life. They represent gifts of food, clothes and the opportunity to take advantage of an education. They represent endurance, hope and promise.

They also represent my many childhood memories and those of a rigid and well-sculptured upbringing. Memories of playing in the field when I was supposed to be working while Daddy was gone to town; listening to the folks at the tobacco bench gossip and talk about their lives as they worked so closely in harmony, stringing leaves as I brought them in from the field. Then there was going to church every Sunday and watching and listening as the tobacco farmers in the community sat around on the steps of Salem United Methodist Church, talking, bragging and worrying about their crops, while the women busied themselves with the real business of church: planning the special functions, holiday meals and dinner on the ground events, trading recipes, remedies, weekly experiences, light and innocuous gossip, et cetera, all while waiting for Sunday school and church to start.

What do the tobacco fields represent to me now? Not just an age-old way of life, but life itself.

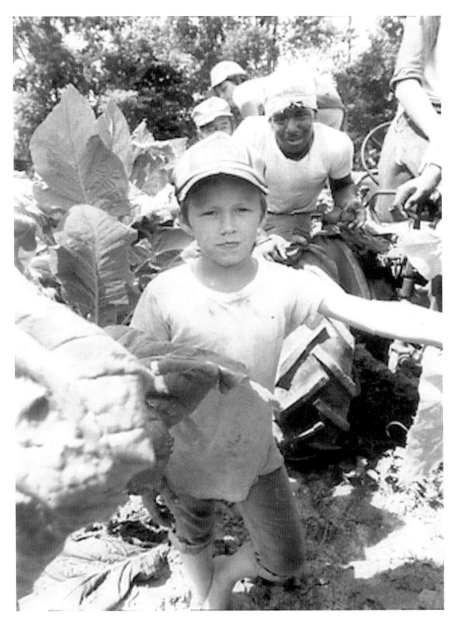

Born and raised in a tobacco environment, this Wilson County youngster works just as hard as the others. Barefoot, hot and sticky, this is an image that has repeated itself from generation to generation.

The Things That
Made Me Who I Am

I first saw the light of day in Huntsboro, North Carolina (named for the ancestors of North Carolina's revered governor, James B. Hunt Jr.), a railroad siding in the Salem Township of east central Granville County. I was fed, clothed, nurtured and educated by the harvests of the long green leaves from the hot fields that were laid out behind the house I grew up in. It was also there that I learned to "cuss," looking directly into the (forty-dollar) rear end of a red mule creatively named "Red."

As a child, there was always the annual repetition of clearing new ground to make way for plant beds and marking the bed perimeters with freshly cut pine logs. Then, before stretching the cheesecloth (plant-bed covers) over the beds, dogwood tree branches had to be evenly placed around inside the logs so the plants could come up and grow without hindrance underneath. Next in line was "picking" plant beds (getting all the nutrient-stealing weeds out). Finally came the time for pulling plants from the bed and transplanting them. This is where I dropped plants in front of the "pegger." Later, I toted water from the wagon to the other field hands, who, being older and more skilled than I, were wielding the hand-held transplanter.

Next came plowing: ridging, lapping, laying-by and "busting" middles. With that, of course, came the ugly and stubborn old mules, who floated along between the tobacco rows on all fours while I stumbled along behind on two wobbly legs, guiding the plow, as best as possible, between the rows, all the while smelling (and dancing around) the digested corn and grass waste they spitefully dropped right in my path. Before you could get ready for harvesting (i.e., "priming," "barning," "cropping," "housing," "filling barns," all depending on what part of the bright-leaf

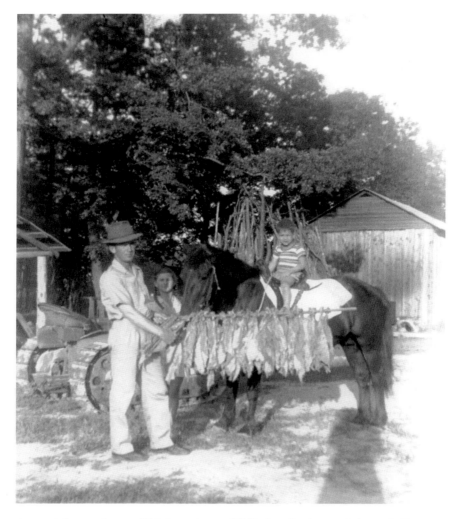

A proud farmer shows off his latest barn of "killed out" tobacco. *Left to right*: Tom Hobgood, of the Huntsboro community of Granville County; his little sister, Betsy (standing) and the author, mounted on "Nellie," circa 1943.

tobacco belt you were in) there was the task of cleaning last year's soot from the barn flues and knocking out pigeon nests from the tier poles that had been built in the spring. Finally, the dreaded day came when we starting pulling "ground" leaves. From that point on, nothing else mattered. Everything—yes, everything—was centered on the tobacco field and the barnyard.

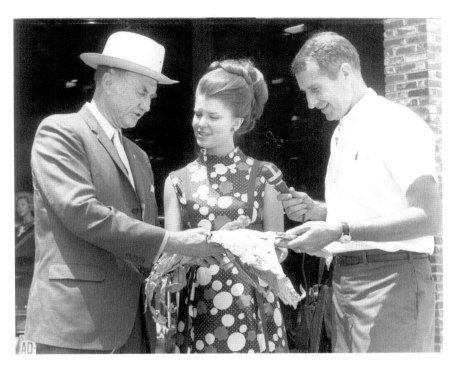

Everybody wants to get into the act. South Carolina Senator Strom Thurmond sneaks over into the Fairmont, North Carolina Border Belt opening celebration and extols his knowledge of tobacco quality with farm broadcaster Ray Wilkinson and a local tobacco queen.

I hated it!! I hated the heat, the sweat, the sixteen-hour days and the strong, loud voice of my daddy yelling upstairs to my cousin and me: "Y'all hurry up and eat your breakfast. We got to take out a barn of t'bacca before we go to the field." I just hated every bit of it! At least at that moment in my life I hated it.

The rewards from those days, which have revealed themselves over these past sixty-eight years, have served me in so many wonderful ways and have crept upon me from so many unsuspecting pathways that I do believe I would enjoy a second trip through those young and mischievous days of my life.

Some of the most vivid recollections of my childhood had to do with things that were so simple, revealing, mischievous, warm and innocent. Simple, like being taught how to drink "spring water" from an elephant's-ear leaf by a wise old gentleman we called "Unca" Otis Marrow; simple, like

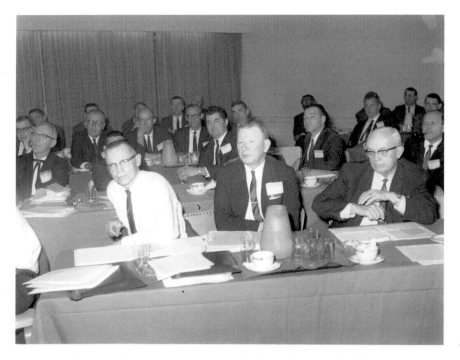

Another gathering of lions. *First row, left to right:* "Zeke" Cozort, Bill Shofner and "Tubby" Weeks; *second row, left to right:* Bill Lewis (future agricultural aid to Governor James B. Hunt Jr.), and Hugh Hardison from Flue-cured Tobacco Stabilization Corp., Inc. listen during a North Carolina State University sponsored tobacco meeting.

spending an evening in my maternal grandfather's (Daddy Mangum) strip house, listening to the soft voice of "Unca" Zeah (Zebediah) Daniel, a ninety-eight-year-old former slave child, as he rambled on about things I didn't quite understand but couldn't get enough of. Revealing, as in learning how to correctly loop a string around the tobacco stick so the tobacco would not slip off when it was pointed upward to be hoisted (heisted) onto the tier poles of the barn. Mischievous, as tying a string around a tobacco worm and then throwing it out to an unsuspecting chicken, who would swallow it, only to be reeled in by me. Warm, like laying my head against my mama's chest and listening to the muffled version of her voice coming through her chest cavity as she talked to my grandmother and reached around my tiny body to gather together the soft leaves to make up a good-sized tobacco bundle, which ultimately wound up on the warehouse floor; warm, like sitting in the middle of the kitchen floor, sopping the uncooked dough from the mixing bowl with my fingers as Mama put the cake layers into the oven. Innocent

(ha!), as when I first learned that both my (older) sisters were horrified of cats and then became the first terrorist in the county by chasing them all over the place with an innocent (and horrified) cat; and innocent, as when Neal, my cousin and I deliberately fed the hogs a mixture of "ship-stuff" and Mama's washing powder. Thank God they refused to eat it; otherwise, I would have died an early (violent and mysterious) death.

The truth is those really were the days that molded my character. Those were the days that made me who I am.

In the Middle Tobacco Belt, situated in that eastern Piedmont area along the North Carolina and Virginia border, we would pull our "tips"(top leaves on the tobacco stalk) each year by late September. When the time was nigh for that, Daddy usually kept some of the help in the barnyard for a few days to finish "barning" the green tobacco, and some headed for the strip house. Once all the green tobacco was barned, everyone took his place around the grading bench in the strip house and they divided themselves into two or three groups. Once the green tobacco was cured and packed down in the pack-house, we began the full-time job of stripping tobacco. Back in the 1940s and '50s, it always lasted from late September through early November, or from the warm weather through the early frosts and until the pear trees had dropped all their pears and the "wimmenfolk" had to go to the house to make pear preserves and other foods for winter storage.

The process of stripping tobacco involved physically toting tobacco from the packinghouse, where, after having been cured, it was packed, or "cooped" down in what we called four-cornered layers. It was then taken to the ordering room for a two- or three-day steaming process, which would soften up the golden leaves so they could be twisted and bent without breaking. When the texture of the leaves softened enough, they were pulled off the stick and stacked onto the grading bench. Then the leaves were divided into three or four grades of quality and tied into bundles according to the grade. With that done, the bundles were placed across a "trimmed" tobacco stick and packed into the back of the pick-up, or onto a homemade farm trailer usually pulled by the family car, and sent off to the warehouse for sale. Not only was this ritual a necessary step in the process of a tobacco farmer's life, but the very nature of it made up those social elements that collectively fused an American tobacco culture.

Most prominent in my mind from those days around the strip house were the pear trees standing just outside the eastern window, next to the woodshed and chicken house. There were four of them, standing between

our garden and one of the farm's larger tobacco fields. They seemed to announce the dividing line between the economy-driving elements of the farm and the cultural-processing elements.

Those complicated abstracts really did not matter to a five-year-old, however. What mattered to us little people at the time was adventure. My mama always said that I was the adventurous one in the family. And I was—even from the beginning. Among all the recollections of my childhood, the one that haunts me the most is the time my rear end suffered its most debilitating blow (or sting).

It happened in the fall of 1944 when, while playing outside the strip house, I got my hands on a box of stove matches, the ones that would light when struck against anything hard. I proceeded to see if they would work. They worked; and they worked right in front of the strip house.

It was cold, dry and windy. I lit the match and it fell into the grass. Being wise and savvy beyond the years of a five-year-old, I panicked! I ran around in a little circle. Espying a large, rusty stew pot a few feet away, I ran over, picked it up, placed it upside down over the growing fire and sat on top of it. The problem was that there was a rusted-out hole right in the middle of the bottom of the stew pot. Imagine that! The weather was not yet cold, so Mama had me dressed in short pants made of thin cloth. Imagine that, too!

I happened to be facing the strip house when the bloodcurdling scream came forth. Four (adult) people came through the strip house door at once and, in two strides, yanked me up into their collective arms, turned me upside down and proceeded to dust the smoke and fire from my short pants. That was the good news. The bad news came as soon as Mama saw that, apart from the fear in my sweet little face, I was not hurt. Half crying from the close call and half laughing at the happy ending, her calloused hands knit out a patterned stinging on my behind that would make a jellyfish proud. This was just the beginning of barnyard experiences that I would remember well and live to tell and smile about, almost seventy years later.

The Thirteen-Month Crop

By Burt Kornegay

That's how much time tobacco farmers say they need to produce and market their crop—thirteen months!

Long ago, tobacco earned its reputation as a plant that required much time and effort to grow. Colonial farmers growled and cussed about the amount of work involved. Today, little has changed in that respect. During the difficulties of the harvest season, farmers carry on something of a contest to see who can most solemnly swear that he'll grow "nary another leaf." However, come fall, they'll be comparing their acreage for the next year.

Although many types of tobacco are grown in the United States today, almost all tobacco farmers follow one general method in planting and cultivating their crop.

Winter is seedtime. Selecting a site protected from wind, the farmer disks, plows and harrows the soil for a plant bed. After sterilizing the bed with a gas that rids it of all insect and plant life, he broadcasts the minute seeds over the worked soil and then covers it with a protective canvas or plastic tarp. Under the warmth of the sun the seeds begin to germinate.

In spring the farmer breaks, fertilizes and ridges the tobacco field itself. When the seedlings have grown about eight inches high, he pulls them from the seedbed by hand and places them in open wooden crates for transplanting to the field. Today most farmers plant the seedlings with a one- or two-row setter pulled by a tractor. The setter forms the row, drops in the plant and waters it. Workers riding the machine feed in the seedlings one by one. Some farmers, however, still use horse-drawn setters, and a few continue to transplant by hand.

"I reckon the tobacco seed is the smallest seed in the world, smaller than the mustard seed. The Bible says that mustard seed is the smallest, but I believe it's the tobacco seed."

"Drinktime's the *only* time of the day for me."

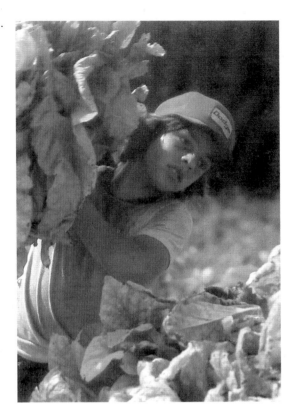

"I tell you, there ain't nothing I dread no worse than to get out in that tobaccer field early in the morning and get that first wet. That feeling of being good and wet—boy, that is a bad feeling."

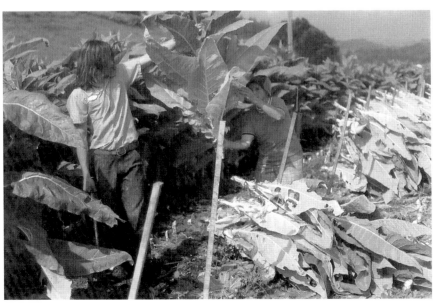

Throughout spring and early summer the tobacco matures, growing rapidly to five or six feet in height and developing a wrist-sized stalk supporting fifteen to eighteen large, arrowhead-shaped leaves. When the tobacco blossoms, the farmer suckers it and breaks off, or "tops," the white flower clusters. Removing the blossoms and suckers forces all the plant's nutrients into its main leaves, making it heavier bodied, more aromatic and better tasting when cured.

In summer the harvest begins. The basic task in harvesting any tobacco is to bring the ripe leaves from the field to the barn where they are cured and, eventually, prepared for market.

Bright leaf is harvested in several ways. Many farmers still use six to eight "croppers" or "primers" in the field. These workers move down the rows of tall tobacco, snapping off the ripened leaves (usually three or four to the stalk) and piling armfuls on wooden trailers. Boys on tractors pull the loaded trailers to the curing barn. Because its leaves ripen in successive stages up the stalk, bright leaf must be cropped once a week in this way. The field is completely stripped of leaves, or "tipped," within six to eight weeks.

If the curing barn is the conventional log or plank type, the farmer's wife, daughters and as many neighbor women as are needed will be taking the leaves out of the trailers and placing them on the conveyor belt of a "leaf stitcher." This machine sews the leaf butts together so that the leaves straddle a tobacco stick. The leaf-loaded sticks are then hung on wooden tier poles over an oil or gas burner inside the barn.

A few farmers continue to have the women "loop" or tie the tobacco— bunched in "hands" of three or four leaves—onto the tobacco stick. Most, however, have been forced to abandon this traditional method in the last few years due to a shortage of labor and rising labor costs.

The most mechanized farm operation today uses a bulk barn in conjunction with an automatic harvester in the field. The harvester, operated by one man, strips the leaves to a certain height on the stalk and deposits them in trailers. Workers at the barn pack these leaves into steel racks or large steel boxes and slide them into the barn.

Leaf-curing, which takes from five to seven days, is the most delicate aspect of tobacco barning. The farmers must inspect the leaves frequently, raising or lowering the heat inside the barn as the leaves color and dry. When the leaves have "cured-out," they are removed from the barn and wrapped in large burlap sheets. Only then, some nine to ten months after the initial seeding, is the crop ready for market. Hardly has the leaf been

sold, however, than the farmer is cutting and uprooting the old stalks in the field and deciding where to plant the next year's crop.

Burley tobacco is harvested just once, in late summer. When the plants have matured, the farmer goes to the field and cuts the stalks at the base. He impales half a dozen stalks on a "spear"—a tobacco stick tipped with a metal point—and lets the tobacco stand in the field for a day or two. When the crop is wilted enough to be handled without breaking, he hauls it to the barn and hangs it on tier poles. Because burley is cured with natural air, no specially constructed barn is needed. The farmer can use any building on his farm if it has adequate tier space and natural air circulation.

When the burley is fully cured—a process taking about two months—the farmer removes it from the barn and strips the leaves from the stalks. He grades these leaves and bundles them into "hands." The hands are piled in wooden baskets or placed back on the sticks ready for market.

Whereas the bright-leaf markets usually open in late July and close in November, the burley markets don't open until December and remain open through the following March. This means that burley farmers often sell their leaves *after* they have seeded the next year's plant bed. Theirs truly is a thirteen-month crop.

Reprinted with permission.

Tobacco Cultivation

By Bruce Woodard

Taking Out Tobacco

"Taking out" tobacco, or removing the sticks of cured leaf from the barn, was not one of my favorite jobs. No wonder the holiness preacher up the road near our farm called it the "devil's weed." He said it was a sin to grow it and even more of a sin to smoke or chew it. But most of his members grew it anyway, and when the collection plate was passed, he took tobacco dollars too.

Taking out tobacco always started early, which on our farm was about 4:00 a.m. The cured leaves had to be taken out while there was plenty of moisture in the air so the leaves would not get too dry and shatter. It was still pitch dark and the rooster hadn't even crowed when we were awakened by the kerosene lamp being lit and Daddy's booming voice saying, "All right, rise and shine! We've got two barns of tobacco to take out!" I usually muttered under my breath, "God made daytime to work and night to sleep. Why do we always have to start so early?"

At 4:00 a.m. in mid-July the air was cool and damp. It took all the effort we could muster to roll out from under those warm sheets and put our feet on that cold linoleum floor. We'd climb into our bib overalls, still yawning and rubbing our eyes, and head down the path that led to the barnyard. The weeds and grass along the path were wet with the heavy morning dew. By the time we reached the barn our overalls were wet to the knees.

Being big enough to straddle the tier poles in the barn seemed to be somewhat of a status symbol among the young boys. Climbing to the top of the barn to take out sticks of tobacco from the top tiers was even more a sign of being grown-up. I was afraid of heights so I always chose to be

the one on the bottom tiers. The tier poles were about four feet apart. I would spread my legs apart with a bare foot on each side and take the sticks of freshly cured, aromatic tobacco as they were handed down to me from the worker in the top of the barn. I then passed them on down to the person who was on the ground, and they were passed out the door to my daddy who piled them on the trailer.

Working on the bottom tiers had some disadvantages. First, you handled every stick of tobacco. Then there was the sand and trash that fell on you from above, as well as the danger of being hit on the head by a stick of tobacco that was accidentally dropped. Another problem occurred when you had on a pair of overalls that had split open in the crotch. It was always cooler when you left your underwear off and just wore the overalls. However, if one of the local girls was below you taking the sticks of tobacco as you handed them down your vitals were in plain view. For some reason the girls liked that job. If Mama was around, she would scold you for putting on ragged overalls and suggest to the girls that they work outside the barn "where the trash would not fall in [their] hair."

Outside, Daddy seemed to take pride in seeing how high he could pile the sticks of tobacco on the trailer. When it was loaded we would walk beside the load of cured leaf and support it as it was hauled to the packinghouse. Here it was unloaded, passed into the packinghouse and piled or "penned" neatly for storage until grading time. You were lucky if you were not needed for unloading. Then you could curl up on the warm barn furnace and take a quick nap. When they returned for the next load someone would kick you in the butt and wake you up. I always assumed that I wasn't needed for unloading at the packinghouse, unless told otherwise, so I could get a short "cat nap."

By the time the last load of tobacco was out of the barns and on the trailer, the tantalizing aroma of country-cured ham and hot biscuits reached our nostrils. It just seemed to float down from Mama's kitchen to us on the cool, morning air. Nothing before or since has smelled so appetizing! We were really hungry by that time anyway. As soon as the last sticks of tobacco were passed into the packinghouse Daddy would be among the first outside. He'd say, "All right, let's go eat! Lord sirmishious, I could eat a whole setting of eggs, half a ham and a dozen biscuits!" Eating breakfast after two or three hours of work taking out tobacco was an experience we all remembered. Mama was a real cook! Her table loaded with country ham, red-eye gravy, scrambled eggs, grits, hot biscuits, butter and peach preserves was ample reward for getting up early

Workers have wrapped up and are preparing to go to the field to begin setting out plants.

and taking out tobacco. It gave us the kind of start we needed for ten hours of hard fieldwork "putting in!"

PUTTING IN TOBACCO

The most pleasant memory about harvesting or "putting in" tobacco was the breakfast Mama served us. It was usually after two or more hours of work, which began at 4:00 a.m., "taking out" a couple of barns of tobacco.

By that time we were famished! Country ham, red-eye gravy, scrambled eggs, grits, hot biscuits, peach preserves and hot coffee was her menu and it tasted awfully good. Everything was homegrown except the grits, salt, black pepper and sugar. It took a good breakfast when you started early and worked hard. Otherwise, you wouldn't last until dinner at noon.

We would finish breakfast around 6:30 a.m. and Daddy would say, "Bruce, take Lawyer and Poodle, go catch the mules, hook to the slides and go to the field." Daddy wanted the first slide truck of tobacco at the barn for the scaffold hands to start on around 7:00 a.m. Lawyer and Poodle Young were the sons of Charlie and Lessie Hawkins Young. They were black sharecroppers on the Woodard farm for many years. I say "black" with reservations. While the term may be proper now, it wasn't then. Lessie gave me a real good tongue-lashing one day when I said their family was black. Times sure have changed! She said in no uncertain terms that they were "colored." They were a nice family, good neighbors and a real asset to the community.

At the stables we hooked up old Rhodie and Rabbit, hopped into the slide truck and rode to the field. "Priming," or pulling off the leaves of green tobacco, was a big job. Early in the morning the tobacco was wet from the heavy dew, and we'd be wet to the skin in just a few minutes. The rising summer sun was a welcome sight since its warm rays would soon take the chill away and dry our clothing. As it got hotter, however, we were soon wet again—this time by perspiration! During the hottest part of the day, usually between 1:00 and 3:00 p.m., we had to be careful not to "let the monkey get us!" This was a common expression used to describe being overcome by the heat. Those who began to get too hot said they felt dizzy and heard chirping noises in their ears; thus the phrase "letting the monkey get you!"

Priming tobacco was not without a little fun. After telling all the jokes, stories and gossip we knew about Gold Valley folks, we'd get to the end of the row and enjoy "rasseling" at least once or twice a day. (That's "wrestling" for you Yankees!) We were pretty evenly matched since our ages and sizes were similar. The idea was to see who could "dirty" the others' backs. I got mine "dirtied" plenty of times, and on other occasions I was the champ. Everything was in fun, and blacks and whites were the best of friends.

Another activity to lighten the day was to "bust" a watermelon. Daddy planted a row of watermelons in the tobacco field so they were conveniently located. We'd drop a melon on the ground and eat the heart

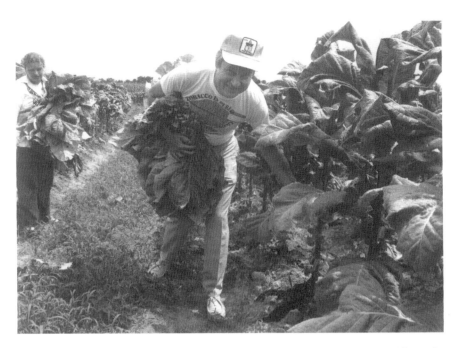

In this August 1978 picture former U.S. Congressman Horace Kornegay, as president of the Tobacco Institute, demonstrates how to add class to priming tobacco.

out of it using our gummy fingers. Then we'd pack a few in the truck of tobacco as a surprise for the scaffold hands. They'd respond by sending us Pepsi-Colas or ice water.

We usually had no watch, but we learned to tell the time pretty well by looking at the position of the sun. Old Rhodie could tell when it was about noon. When headed south towards the rows she was slow, but headed north toward the stable she'd move like lightning. When headed away from the stable she moved at a snail's pace, but when we turned her around, we'd have to holler "whoa" several times to stop her. At least once a season Rhodie would rebel. Instead of stopping she would just take off in a gallop and "run away." She always headed for the stable and usually the slide truck of tobacco would turn over and we'd lose tobacco leaves. Rhodie would stop under the apple tree next to the stable. Here she could get a snack of green apples before we put her in the stable for her usual noon meal of corn and hay.

Daddy was in charge of the scaffold help at the barn. He supervised the handing, stringing or looping and dracking of the filled sticks of green

leaves. Lessie Young took pride in being the fastest looper. Before I was old enough for priming my job was handing the leaves from the slide truck to Lessie for looping on the sticks. Each looper had two or three handers. Lessie would grab the bundles of three or four leaves as fast as they were handed to her. Her lower lip was usually packed with "Sweet Peach" snuff. She'd say, "Y'all put it to me now—I don't like to wait!" This would encourage us to try to hand faster than she could take it, so we could retaliate by saying, "Come on Lessie, take this backer and don't make us wait!" This didn't happen often. Lessie could keep a fast pace longer than we could.

Lessie hated anything that slowed her down. Occasionally the string would break, and she'd fuss about "that old sorry two-ply twine that Mr. Ollie bought. He ought to buy four-ply twine." During the war years it was hard to get any type of twine, so if only two-ply was available that's what we had to use. Another pet peeve Lessie had was a crooked or a limber tobacco stick. When she picked up one and put it on the stringing horse she'd immediately break it and pitch it aside. She'd say, "Now I won't be worried with that one anymore!"

By late afternoon we'd have enough sticks in the racks or piled down to fill one or two barns. Daddy would send word by the trucker to come in from the field and "hang" the tobacco in the barn. The heavy sticks of green tobacco were passed bucket-brigade style into the barn. Since the inside of the barn was hot from the July sun, hanging a barn or two of tobacco at the end of a day that began at 4:00 a.m. was no fun! It was a hot, tiring experience. We would usually finish around 6:00 or 7:00 p.m.

After a late supper we'd take a bath in a tin washtub on the back porch using homemade lye soap. Later in the 1940s, after we got electricity, it became a cold shower using the garden hose stuck through a hole in the back of the wash house. An inside bathroom with hot, running water was not put in until much later. No one had to be coaxed to go to bed. It seemed good to climb into bed by 9:00 p.m. after a long day that had started at 4:00 a.m., seventeen hours earlier. I tried to go to sleep as quickly as possible. I knew that 4:00 a.m. the next morning would come soon, with more "taking out" and "putting in."

Some nights it was hard to sleep. After working so hard and long, your muscles would ache and often cramp up. When you did get to sleep, you'd probably dream that you were still working. So you'd wake up tired. But one thing we could count on were the first words we'd hear the next morning from Daddy—"All right, rise and shine!" I usually managed to "rise," but it was awfully hard to "shine."

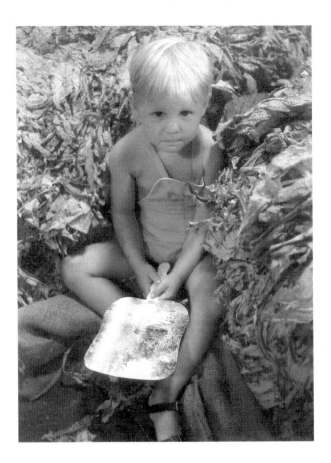

GRADING AND SELLING TOBACCO

Soon after tobacco harvesting was finished it was time to get the cured leaf ready for market. This was usually around the first of September. The fall season came in with days beginning to shorten, trees taking on their bright colors, scuppernong grapes and figs ripening and the air becoming cool and brisk. Tobacco was sorted or graded in the packinghouse. We took the radio with us for entertainment during the long hours we worked, both day and night. Our listening included soap operas like *Stella Dallas*, *Portia Faces Life*, *Ma Perkins* and *John's Other Wife*. Other radio programs that appealed more to the boys were *The Lone Ranger*, *Sky King*, *The Hermits Cave*, *Henry Aldrich*, *Fibber McGee and Mollie*, *Amos and Andy* and *Lurn and Abner*. On Saturday nights we always tuned in to hear the *Grand Ole Opry* in Nashville, Tennessee.

The sticks of golden yellow, aromatic tobacco were taken off the pile and passed down into the ordering pit below ground under the packinghouse. They hung there overnight and the high humidity caused the leaves to pick up moisture or "come in order." This made them soft and pliable so they could be handled without shattering. The sticks of leaf were taken out a few at a time the next morning. The youngest boy's job was to "take off" or remove the leaves from the sticks. The sticks were placed one at a time on a looping horse. The string was broken at one end and the cured bundles were taken off and handed to the graders, who sat behind a grading bench. The bench had holes about twelve inches apart with a smooth grading stick inserted to form five or six sections for the different grades of leaf. The graders would pick up one leaf at a time, spread it open and then place it in the appropriate grade based on color, size and texture. Grades might include bright lemon, orange, light green, dark green and brown. Black or trashy leaves were pitched out the window behind the graders. This was later put around our peach trees to prevent borers or in the mule stable for bedding.

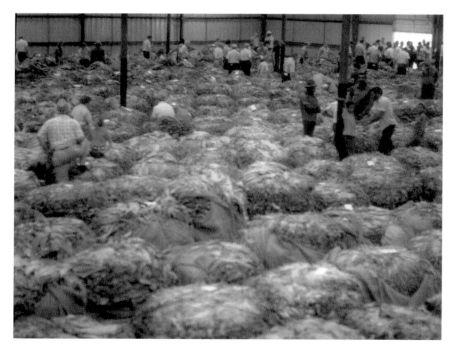

This vast sea of gold has represented the wealth of America, courtesy of the tobacco farmer, since 1612.

The tiers took the leaves of each grade and bundled them up in bundles about one inch in diameter with the stems together. Then they tied them by wrapping a folded leaf, a wrapper, around the stem or heads of the leaves. They started with the tail and ended with the stem pushed through the middle of the bundle to hold it. The longest, highest-quality leaves were used as wrappers. The tied bundles of each grade were then packed down and covered with a sheet to keep them "in order." That night the last job was to "stick up" the tied tobacco. The bundles were spread open and placed across a smooth grading stick, pushing them as close together as possible. When the stick was full it was laid down on the floor and pressed under a twelve-inch board with one of us providing the weight. Some folks used wooden presses with a lever to compress the tobacco, but we never owned one of those. The pressed sticks of tobacco were piled down and covered up with sheets or old quilts to keep them in order. When Daddy figured we had a trailer load, the sticks of tobacco were placed on a trailer, covered with a tarp and pulled to market.

As we pulled the trailer load of tobacco down the street in Rocky Mount behind our old Hudson, warehousemen would be out front waving their canes and hollering "drive on in!" When you drove in workers would swarm over the load, taking off the tarp and then unloading the sticks of tobacco. The tobacco bundles were slid off each stick and laid in perfect order on large, flat wooden baskets that sat on two-wheeled tobacco carts. When the basket was full it was rolled to the scales for weighing. The Salvation Army lady was usually present near the scales, accepting donations of a bundle or two of tobacco to be sold for the benefit of the needy. After weighing, the baskets of tobacco were placed in long, straight rows ready for the auction sale.

Before the auction sale began "Peg Leg Sam" entertained the crowd with his harmonica. He was an old black man on a wooden leg who became a tradition on the Rocky Mount market. I remember his rendition of the fox hunt. This was a tune that sounded like a real fox chase with the hounds barking as they chased the fox. Sam sometimes placed the whole harmonica in his mouth as he played. People threw a few coins into his hat in appreciation.

It was time for the sale. The auctioneer had a unique chant as he moved down the row selling each basket of tobacco separately. The buyers followed along bidding on the baskets they wanted. Each buyer had his own signal for bidding—a pull on the ear, a finger in the air, a slap of the chest, et cetera. Each carried a sweat towel hung over his belt. It was usually hot inside the warehouse, so the towel came in handy. A ticket marker followed behind the buyers. He not only marked on each

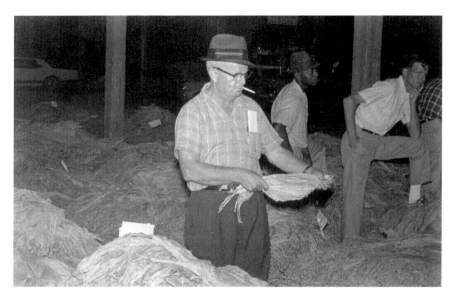

Alton Boswell, sales supervisor from Wilson, North Carolina, whose job was to maintain organization and expediency in sales on the Wilson Tobacco market.

ticket the bid price and buyer, but he also calculated in his head the total amount for the basket based on weight and price per pound. Since a basket was sold every eight to ten seconds, this was an amazing feat! The ticket marker was a walking calculator.

After the sale, Daddy went by the office to pick up the check. He would head straight to the bank to get some "new" money for his pocket and to deposit the rest. Those not fortunate enough to go along to sell the tobacco stayed home and graded more. It was a welcome sight to see Daddy walk in the packinghouse door and say, "Well, it sold right good today!" Then he'd hand us each a bag of candy. Kids back then seldom had store-bought candy, so this was a real treat. I remember the orange peanuts, gumdrops, peanut brittle, sugar wafers, gingersnaps and peppermint sticks. No cookies we got, however, were as good as the big vanilla and lemon teacakes that Mama made and kept stored in a white cloth flour sack in the bottom of our pie safe.

Grading and selling tobacco was the climax to a year of hard work. The treats of candy and cookies were well deserved. But we also got a pair of new brogan shoes, a denim shirt and a pair of bib overalls for starting back to school. The really hard work was over for a while, and we knew it would soon be Christmas!

The Tobacco Auctioneer

Aside from the attraction of new community businesses, tobacco marketing lends another cog in the social and political wheel that, unlike the others, has escaped all the problems plaguing the industry: the tobacco auctioneer himself.

Traditionally, more than anyone else, the auctioneer determines the farmer's economic plight for the year. He is the one who squeezes the last penny out of the buyer. This is the deciding factor that gauges the farmer's economic return for a year of careful planning, grueling work and abiding faith in the general climate; namely, enough rain to make the crop grow and mature at maximum weight, marketable texture and quality.

The auctioneer's predecessor was the inspector or "crier." He was a government-paid public servant. His job was to establish fairness in terms of tobacco quality. With the inspector's failing credibility there came another opportunity. It was that of the independent tobacco auctioneer.

H.B. Montague, a Henderson, North Carolina native, emerged as an independent auctioneer. Montague saw the increasing demand for a professional and private individual to bolster competition among buying firms. In March of 1827, he advertised himself as an "Independent Tobacco Auctioneer"; one of integrity and honesty who would not "knock out a pile of tobacco as long as there was another bid on the floor." Between Montague's emergence as a commercial auctioneer in 1827 and the appearance of the "Danville" system in 1858, independent auctioneers became more numerous.

The style of the early auctioneer is, in part, due to the lack of necessary expediency in the old market square. There, it was executed in a slower and less theatrical mode. Also, with the exception of a few planters who brought along one of their musically talented slaves to amuse buyers and

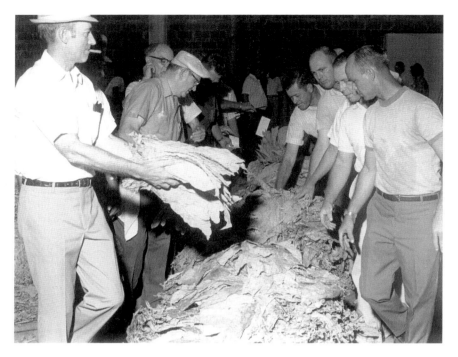

One of the greatest drawing cards to a tobacco sale was the auctioneer. In this picture, Ray Oglesby, one of the five "Lucky Strike" tobacco auctioneers, gets down to business at Farmers Tobacco Warehouse in Greenville, North Carolina, as Arther Tripp leads the sale.

entertain the gathering crowds, transactions were made in a "business as usual" spirit.

With the simultaneous emergence of the new loose-leaf selling method and the post–Civil War surge in national tobacco demand, increased competition dictated that warehousemen design creative ploys to attract more business to their warehouses. This included giving the auctioneer an expanded responsibility of soliciting customers. He spent a good portion of the day standing at the big door in front of the house, or out on the street, enticing passing farmers to bring their crops in to be sold in quicker time and for higher prices. Using the theory of humor to solicit trade, the auctioneer honed his talents to a fine point. He continued his clowning act as he chanted for the highest dollar on sale. Thus, a novel and everlasting cog in the tobacco wheel was created!

The auctioneer as a keen, competitive and entertaining salesman took his permanent place in the tobacco marketing process. His act was rooted

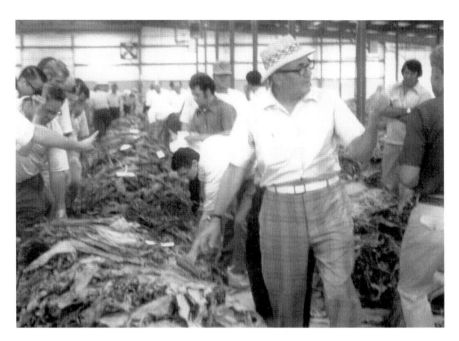

Legendry tobacco auctioneer Maynard Talley mesmerizes the buyers with his rapid-fire auctioneer's chant on the Durham, North Carolina Tobacco Market, circa 1940s.

in many areas of history, including religion and social rituals. His gestures were similar to the medieval entertainer, the chant of the soothsayer, seer and sage or the barker at a street medicine show. But his role was based on a very serious premise: winning long-term customers for the warehouse by squeezing every possible dollar from that buyer across the row. Also, with increased demand and responding production, tobacco sales elevated to a much faster pace, both in terms of sale frequency and the need to move a large daily volume. This added yet another responsibility: to allow the house to offer constant product to the buyers and maintain fast turnover for the warehouse. In the process, the warehouseman boosted his profit by selling the entire floor in a hurry, filling up and selling again. Fast-paced sales provided the additional advantage of preventing warehouse congestion at a time when warehouses were being flooded with farmers and their crops waiting to be sold. (This is known in tobacco circles as "keeping the pipeline" open.) The sales process involved persuasiveness and the critical element of the auctioneer's speed and ability to catch bidding signals from the buyers.

Characteristically, auctioneers are businessmen as well as entertainers. They have always been unique experts in the art of salesmanship. No doubt they have spent many hours privately practicing colorful chants and attention-getting antics, both of which would effectively stimulate exuberant bidding competition. Equally so, they were constantly tuned in to the crowd of onlookers who, more often than not, were prospective customers and good sources of "word-of-mouth" advertising. Those who entered this field, especially the ones who expected to become the best, and ultimately the most sought after by farmers and warehousemen, continually had to hone their skills and create innovative ways to draw attention to themselves and their employers.

Chiswell Dabney Langhorne, a native of Lynchburg, Virginia, and a post–Civil War resident of Danville, Virginia, is recognized as the father of the modern-day tobacco auctioneer. "Chillie," as his family knew him, was a maternal cousin of Confederate General J.E.B. "Jeb" Stuart and, reportedly, a cousin of Mark Twain (Samuel Langhorne Clemens). A handsome Southern aristocrat, he eagerly responded to Jeb Stuart's call in 1862 to "Jine the Cavalry" and served as a Confederate soldier throughout the war. Later in life, he became quite notable for having fathered eleven children: six girls and five boys. All the girls did well in life and, by comparison, all the boys did not. Nancy, who was born in 1879 and was Langhorne's favorite, proved to be the most ambitious of all her siblings. She married into the Waldorf-Astoria family and retained the "Astor" name for her entire life. Later she moved to England and became the first female to take a seat in Britain's House of Commons. There, "Lady Astor" dedicated herself to representing England's Sutton district from 1919 to 1945, during which time she became one of Sir Winston Churchill's major antagonists. (In a fit of anger she once remarked to Churchill, "Sir if you were my husband, I would put poison in your coffee," to which he replied, "My dear Madam, if I were your husband, I'd gladly drink it.") After her tenure in British Parliament she remained in England until her death.

Chillie was full of jovial laughter and pranks, and constantly amused his friends. After the War Between the States he found employment in Danville as a night clerk in a local hotel. The endless boring nights behind the front desk, however, proved to be too much for Chillie. Once, at two o'clock in the morning, when his craving for fun and laughter finally overwhelmed him, he rang the fire bell, which alerted the guests that the hotel was on fire. As they made their way through the lobby and out the

door, he delighted in turning the water hose on them. Daylight found him looking for another job.

Next, he rounded up several nondescript horses and launched a career in the livery stable business. Apparently this venture carried with it the same boredom as the hotel business. Soon he began to display one of his newly discovered talents: an esoteric, rhythmic and entertaining chant laced with numbers and stimulating sounds that had not been heard before.

The late Senator Sam Erwin claimed to know how Langhorne came about this auction-chanting renaissance. (His theory is supported by Sanford, North Carolina tobacco auctioneer Jimmy Morgan, who told me in an interview that he was one of Langhorne's distant relatives.) In a 1980 conversation, Senator Erwin stated that he learned from extensive research conducted long ago that Langhorne formulated his "gobbledygook" chant after first hearing the "Gregorian" chant of ninth-century Pope Gregory while attending a Catholic Mass with a friend in Richmond. According to Erwin, Langhorne reasoned that if he used the Gregorian-laced chant, incorporated into it a rhythmic staccato and, at the same time, effectively satisfied the needs of the market trend, he would attract more farmers and incite buyers to higher prices. His theory proved to be right and, at once, Langhorne, with his chanting innovation, was in constant demand by warehousemen.

Auctioneering didn't interest Langhorne for very long, however, and he soon answered the call from former Confederate General Kyd Douglas to move into a lucrative lifetime career as a railroad man in Bremo, Virginia. Even though his tenure in the tobacco industry was short-lived, his entertaining approach changed the entire definition of the tobacco auctioneer. Ultimately, a jovial and festive air became an integral part of tobacco marketing. The stage was set for those who followed. From that point in history, the warehousemen set a prerequisite of comedic and entertaining talents for anyone seeking the job of auctioneer. To a large degree, this necessarily changed the required nature and characteristics of prospective tobacco auctioneers.

Soon after Chillie's departure from the industry, other tobacco auctioneers began imitating the style he designed and ultimately adopted it as the only effective way to sell tobacco. Those who could not quite imitate Langhorne's chant attempted to compensate in other ways. In the early 1880s, Frank Barfield of Durham, North Carolina, would arrive at the warehouse dressed in flashy clothes, wearing a silk suit, bright red vest, top hat and carrying a brass-knob walking cane. He would often stand at the warehouse door,

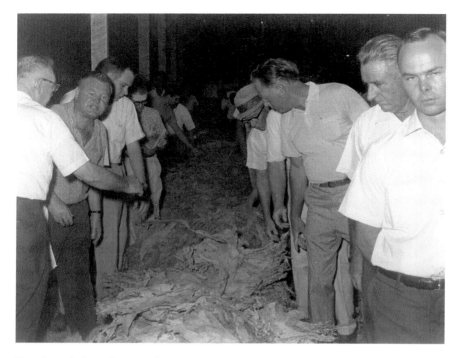

Two legends in action: warehouseman Roy Pearce and auctioneer Champ Batchelor, both North Carolina tobacco men, selling tobacco in Pearce's Warehouse in Valdosta, Georgia.

gesturing with his cane and calling to the driver of a wagonload of tobacco headed for some other market. He would mingle and talk with the farmers, who awaited the sale, and assure them that he was the best there was and that their tobacco crops were in good hands as long as he was the auctioneer who sold them. Just before the sale he would thoroughly work the crowd and then lead the buyers to the starting point of the sale. With the signaling of the start of the sale by the sounding of the horn or bugle, he would exuberantly twirl his cane and proceed with his unique method of chanting for bids. Thus the modern-day method of chanting began: skillfully entertaining the crowd, taking the bids, pushing up the price and prodding the buyers to squeeze just one more penny per pound.

Aside from Langhorne, and later Barfield, there were others of the era who earned an industry-wide reputation. Captain E.J. Parrish of Durham, North Carolina, was an auctioneer whose initial claim to fame was that of a bartender and Methodist preacher. Another was Captain A.J. "Buck" Ellington who got his start in 1875 at Piedmont Warehouse in Reidsville.

Ellington was known for his fine voice and was considered to be one of the best tobacco auctioneers in the South. He was often referred to as a "power on a tobacco sale."

Washington Duke had built the first tobacco factory in Durham after the Civil War and, along with his sons James Buchanan "Buck," Benjamin and Brodie, he had gone after the lucrative tobacco trade with unprecedented aggressiveness. To a large degree the Dukes played the leading role in introducing tobacco markets to areas other than Virginia, Maryland and North Carolina. By the turn of the twentieth century, tobacco was being produced in South Carolina, Georgia, Florida, Kentucky, Louisiana and Missouri. Duke's success accomplished, among other things, more widespread use of tobacco and keener competition from other tobacco dealers. The ultimate result was a larger demand for the raw product, expanded production areas, increased competition on the warehouse floor and, of course, the need to establish markets in new production areas. This widened the field for tobacco auctioneers.

Sixty years after Langhorne, heirs to that chant had hashed and rehashed it on the warehouse floor to the extent that, while the basics were still there, it was fine-tuned to an art. Langhorne, Barfield, Parrish, Ellington and all who followed after them into the twentieth century would be classified as amateurs compared to the professionals of today.

Most auctioneers knew each other and were friends. In those days, as today, there was a feeling of close kinship. Auctioneers who came along at the turn of the twentieth century were influenced by those who started out behind Langhorne; one example was Garland Webb, who displayed the Langhorne influence at Farmers Warehouse in Durham in 1883 and later in Winston-Salem, then in the Coastal Plains area. Others were Mat Nelson and John C. Neal of Danville, the latter being the son of Thomas D. Neal, one of the originators of the loose-leaf auction system; John Abe Newson of Winston-Salem; Francis Hicks of Henderson; Keaton Watkins of Warrenton; and "Tug" Wilson and Captain Tom Washington of Wilson. Some historians have characterized the auctioneer as a kind of "official jester" for entertaining the crowd, but his more serious duty was to set the pace for sales. Even so, the auctioneer was always entertaining and given to spectacular performances, but he never failed to interpret the winks, nods, salutes or other signals used by the buyers as bidding methods.

Even though the auctioneer has earned the reputation of being hard-living, fast talking, lighthearted and funny, the very serious responsibility of selling tobacco at the highest price available never

leaves him. He is dedicated to his purpose. Through all the antics, he is an important businessman. He takes seriously his responsibilities to know the quality of tobacco on the warehouse floor, to know which of the eight to eleven buyers across the row is interested in a certain quality or grade being offered at the moment and how much they might bid. He must keep up with who is bidding in competition; he must keep his customers in mind; and, while he is chanting at the rate of three to five hundred words a minute, he must know when to "knock" a pile of tobacco to a buyer. Anywhere from $150 to $400 is turned over on the warehouse floor when a pile is sold. And one is sold every three to five seconds. That adds up to hundreds of thousands, sometimes millions, of dollars per day. So, it is easy to see that this critical member of the process, while attending to his entertaining responsibilities, is also astute in conducting serious business.

Oftentimes the auctioneer and buyer played teasing games and pulled pranks on each other. Harold "High Dollar" Daniels of Nelson, Virginia, a veteran of most flue-cured belts and burley markets, tells about a 1950s incident when he had to deal with one particular buyer who, for one reason or another, couldn't be satisfied. He had a habit of regularly stopping the sale and complaining.

> *I kept telling him that he was getting on my nerves and that if he didn't straighten up and quit stopping the sale that I was gonna break him sooner or later* [High Dollar said]. *He wouldn't listen, though, so one morning I stuck a pistol that fired blanks in my pocket and when he started in on me again, I warned him. Finally I told him that if he messed with me again, I was gonna shoot him. He didn't believe me. He kept right on. In the middle of the row he started whining. I reached into my pocket and pulled that owl head special out and BANG, I shot him! He fell right across the row! He thought he was dead for sure. The other folks on the sale knew what I was doing and they all killed themselves laughing. From that day on he left me alone and we were friends from then on.*

Auctioneers also had to deal with a lot of warehouse distractions that occurred while the sale was going on. Jimmy Jolliff, the legendary auctioneer from Smithfield, North Carolina, likes to tell the story about auctioneer W.P. "Bud" Chandler from Reidsville, North Carolina:

Bud was in high gear one day [said Jimmy], *and this young boy was walking alongside the sale selling peanuts. Every now and then he would yell out, "Peanuts for sale." Bud tried to ignore him. Finally he stopped the sale and turned around to the boy and said, "Son can't you see I'm trying to sell tobacco here?" The young boy said, "What the hell do you think I'm trying to do with these peanuts?" That brought the house down. And being the good sport he was, Bud bought the whole supply of peanuts from the boy and gave 'em to the crowd.*

Bob Cage of South Boston, Virginia, was the only tobacco auctioneer invited in for a personal visit with England's Queen Elizabeth. In the early 1960s, while he was working the South African market of Rhodesia (now Zimbabwe), he made a record that explained the auction process. The recording imitates several of the older auctioneers who sold during the 1920s, '30s and '40s. Cage tells about the clowning done and how the auctioneers got their respective nicknames. "Dancin'" Jakey Taylor of Robersonville, North Carolina, according to Cage, "would dance up and down the rows and sometimes yell out 'Dance with me, darling!' and 'I just can't dance in these tight pants.'"

Cage talked about others, such as Woodrow Bradshaw. "He was one of the best in the business," said Cage. "He ran a tight sale and kept things going at a pace that would get tobacco sold without having to stop and go back and resell so many piles. He would talk and kid with the buyers. He knew how to create competition."

Cage's debut as an auctioneer was a bit different than some. Most aspiring auctioneers grew up around the warehouse, either coming with their father to sell a load, or being inspired by the atmosphere or the sound of the chant. Cage was introduced to the business by his stepfather. Once the "bug" hit, he decided to spend time getting professional training, part of which, he said, was to learn to use different gaits, octaves and tones while chanting. This was important for endurance on the sale. "It was tougher then than it is now," he said. Cage also pointed out that the support of the warehouseman is critical. "If there is a problem with one of the buyers over a bid and you're out on a limb, you're in real trouble if the warehouseman doesn't stand behind you."

The likes of "Dancin'" Jakey Taylor, "Bum-Bum" Leggettes, "Redcap" McLaughlin and others who came up through the ranks during the 1920s and '30s provided the transition from Langhorne's era to what we hear on the floor today. "Smokey Joe" Burnette of Buffalo Springs, Virginia,

whose career spanned from the 1930s until his death in March of 1965, is considered by many of his peers to be one of the best of the twentieth century. He was one of the highest-paid auctioneers in the business at the time.

Joe was a tall and handsome man with reddish sandy hair and a mellow baritone voice that could be heard all over the warehouse. When he was in good form and tobacco was selling well, his chant sounded like a fast-paced John Deere tractor. He could walk onto a sale, take command and lead a set of buyers anywhere he wanted. Occasionally he would break into a song as part of his style of chanting on the sale. If the mood was right, he would finish the last pile on one row and, before starting the first one on the next, lead a few of the buyers in a chorus or two of a good Southern gospel song.

Joe and the others heretofore mentioned simply make up highlights in the volumes of talents and humorous events experienced by these masters of the esoteric chant. There is one more individual who, like "Chillie" Langhorne, had an abbreviated tenure on the warehouse floor and then went on to bigger things, but who, unlike Langhorne, stayed in the tobacco industry. It is safe to say that this man has had at least as much influence, if not more, on the tobacco auctioneer as did Langhorne. His name was Riggs.

In November 1937 George Washington Hill Jr., the president of American Tobacco Company and a promotional genius, felt the competitive heat of Liggett Myers and R.J. Reynolds breathing down his collar. He needed a new and innovative advertising twist for Lucky Strikes, his leading cigarette brand. He was especially attracted to the chant of the auctioneer and considered using it in his advertising program.

Hill chartered a New York train to Liberty Warehouse in Durham, North Carolina, to hear firsthand an auctioneer whose reputation as one of the best, and especially the best sounding, had spread across the tobacco belts. He had heard that this man from Goldsboro, North Carolina, was faster than any other and could stimulate the buyers and especially entertain the warehouse crowd. Upon arriving at Liberty Warehouse, Hill remained as inconspicuous as possible so he might listen to this auctioneer perform without the pressure of knowing there was such a high official from a major tobacco company in the crowd.

After only a few moments of listening to Lee Aubrey Riggs, Hill's imagination and genius advertising fluids began to flow. With that melodic chant, he thought, a brilliant advertising campaign for Lucky

Strike cigarettes could be created. When the sale stopped for a short break, Hill borrowed the use of Mr. Frank Satterfield's (the sales manager) office and invited Riggs in for a conference. He was brief and to the point.

"Young man, I like what you got," he said. "How'd you like to come to New York and go to work for me?"

"I dunno," said Riggs, "I'm contracted to Mr. Satterfield here at Liberty and I don't see how I can leave anytime soon."

"That's not a problem," said Hill. "I've made arrangements with Mr. Satterfield to get a relief auctioneer and you won't have to worry about leaving him in a bind."

"I can't do that," said Riggs. "I've got to stay around until the season is over and see about my daddy and our farm in Goldsboro."

"OK," said Hill, "but do you think you might be interested in coming up to see me after the market closes here?"

"Yessir, I guess I can save up enough money to come up there for a day or two between now and the first of the year."

The gathering of lions. *Left to right*: Joey and R.C. Coleman, warehouse leaders from North Carolina's Border Belt, along with Fred Royster, the "Godfather" himself of Henderson, North Carolina, study the situation at hand as some young USDA whippersnapper reads the "riot act" to the tobacco industry.

"Don't worry about the money," Hill replied. "I'll take care of that. One of my folks will be getting in touch with you between now and Christmas and we will work out the details."

On November 21, 1937, American Tobacco Company wrote to "Speed" Riggs, as he had now come to be known, and said, "We would greatly appreciate it if you could arrange to be in New York on the morning of December 27th to appear on two or three of our radio programs on the 27th and 28th."

Speed accepted. His radio debut on the morning of December 28, 1937, marked the introduction of the tobacco auctioneer to a national audience. Heretofore, the tobacco auctioneer had only been heard in the flue-cured and burley belts. His chant had never been heard west of the Mississippi. They had only heard the cattle and land auctioneers whose chants and methods of selling goods were derived from the Old English style of auctioneering.

The national debut of the tobacco auctioneer's chant drew quite a phenomenal reaction from the American public. "Speed" Riggs's melodic and staccato chant became immensely popular on *Your Lucky Strike Hit Parade*. Within three years this unique talent, along with Hill's promotional genius, helped catapult the Lucky Strike brand of cigarettes ahead of all others in total sales by a margin of two to one. Not only that, but tobacco auctioneers far and wide were thrilled by it and, for decades, many attempted to mimic it. Hill had taken this relatively inexperienced country boy off the warehouse floor and given him, as well as the Southern tobacco auctioneer, national acclaim. Hill made sure Speed's introduction was very simple and personable. He was always to be introduced as: "L.A. 'Speed' Riggs of Goldsboro, North Carolina." The Lucky Strike commercial was always tagged with the phrase: "Sold American." This creation by Speed remained a household phrase for more than thirty years.

The Warehouse Scene

Just as each social atmosphere changes from one era to another, the climate at the tobacco market constantly changed with the progression into the mid-nineteenth century. However, the tone set by the "Danville System" in 1858 has lasted well into the early twenty-first century.

The physical structure of the loose-leaf tobacco warehouse in Danville was larger than most previous structures and, for the most part, larger than many other small-town buildings of that time. The builders anticipated a multiplicity of future uses and made it suitable for large gatherings, not only for the sale of leaf, but also for political, social and religious events. To a great extent the success of these types of functions was determined by the size of the crowd. In turn, the latter was determined by the size of the facility and the extent of protection from unfriendly natural elements. Naturally, tobacco warehouses became year-round community gathering places.

Of course the daily tobacco sale was the attraction for local merchants and others who had a vested interest, but everyone who had duties there felt the importance of the warehouse as a "social crossroads." Even after the daily sales ended, which, well into the 1960s, was usually late in the afternoon, businessmen, farmers, buyers and others continued to mill around. When dark came, the activities were mostly reduced to a few functions: unloading tobacco for the next day's sale; buyers, auctioneers and warehousemen playing cards, talking business and having a few drinks; and some local entertainer seeking to draw the crowd's attention to his dancing and singing talents.

Thomas Burt, a Creedmoor blues singer whose career spanned from the 1920s into the 1980s, tells about working at the "Bull Factory" (American Tobacco Company) in the '30s and '40s during the day, and then hitchhiking to a local warehouse in Creedmoor, where each night he set a coffee can on the floor in front of his chair and played the guitar

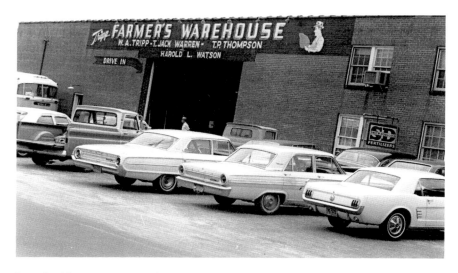

Most budding or veteran tobacco warehousemen went to great lengths to create the most appropriate names for their new warehouses. However, creativity was not the most sought after talent among tobacco warehousemen. Notice the repetition among the flue-cured tobacco warehouses (Farmers Warehouse).

and harmonica and sang the blues while, from time to time, the audience dropped a few coins into the can. Occasionally, if the money was slow coming in, someone would pass the hat on Burt's behalf.

When the warehouses closed in Creedmoor, Burt moved his moonlighting business to Durham.

> *Drunks didn't mind paying me to sang* [sic] *for them* [he said]. *Sometimes they would put money in my guitar. Sometimes they'd get drunk and want to fight, but they never did bother me. They'd just fight amongst themselves for a while and then make up and go and have another drink and come back and dance. I didn't care as long as I could make me two or three dollars a night. When they'd come in late in the evenin' and early night, they'd unload their tobacco, put the horses and mules in the stable under the warehouse and head straight for a drink o' whiskey. After they had a chance to get to feeling good, they'd come back to the warehouse and look for something to do. They'd stay up half the night carrying on. The crowd would get so big I'd have to find a box to stand on 'fore everybody could hear me sang.*

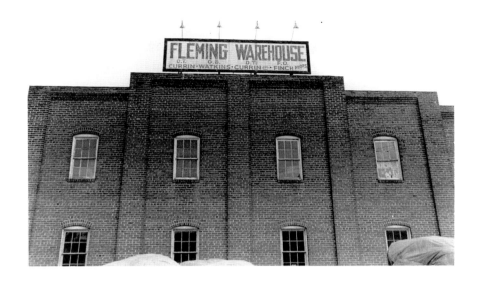

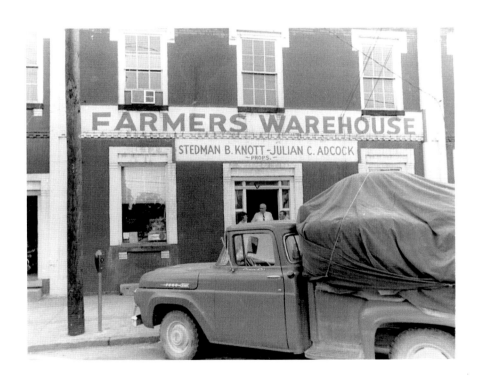

One of the most prominent memories of my childhood in the mid-1940s is listening to the tobacco auctioneer's chant in the Old Banner Warehouse in Oxford, North Carolina. Even today, I remember the intense thrill I felt at the sound and rhythm of his music. I remember that the excitement of opening another tobacco marketing season in town delighted everyone's hearts and brought all classes of local townsfolk and countrymen together in harmony, goodwill and fellowship. There was an air of intense excitement preceding the start of the auction. Young and old, black and white, rich and poor mingled together as the warehouseman gathered his sales team and the buyers around the first pile of tobacco. Either the warehouseman or his sales leader would scan the crowd for sales staff, or any buyers who were out of place, and yell, "Let's go, gentlemen." After allowing a minute or so for everyone to find their places on the sale, the warehouseman would turn to the buyers and give them his presale pitch.

"Gentleman," he would say, "There's a right good break of 'bacca heah today. I want ya'll to pay good 'tention to it." With that, he faced the buyers across the row and yelled out the starting price of the first pile. The auctioneer's reaction set into motion the machinery of the tobacco auction system. As a general rule, the auctioneer already knew the price the warehouseman would put on the first pile because the auctioneer and warehouseman did their homework well ahead of the sale by walking the floor, identifying each crop by the owner's name and carefully matching together quality and price. A "crop" is one or more piles of tobacco brought to the warehouse by the farmer for sale on a particular day. The following week the farmer may have another crop on the floor that consists of a few piles from the same fields and might be lower stalk, or "first pullin'," or perhaps the second or third pulling, and so on. The auctioneer is already in gear as the warehouseman cries the starting price for the first pile, his eyes dancing up and down the line of buyers.

Simultaneously, the auctioneer begins his signature chant. No two chants are alike. From time to time, an auctioneer will attempt to mimic others who might have gained some legendary status. But try as he may, he is never successful. Sooner or later he will always fall back on his own natural and comfortable chanting style. One exception to this is the continuous attempt to imitate the style of legendary auctioneer L.A. "Speed" Riggs of Goldsboro, North Carolina.

As the auctioneer springs into action, the buyers follow up with energetic gestures of bidding. Suddenly, the scenario changes; as the

crowd turns from its jovial nature to one of being quite observant, it transforms itself into a quieter mode. There is almost an immediate hush as the crowd watches the buyers compete for the best tobacco at the lowest prices possible. The auctioneer, settling into the sale and getting comfortable with the situation at hand, bears down on his trade with the air of a charismatic preacher.

Those people across that row of tobacco were his friends. They were his nighttime poker and drinking buddies, but on sale, it is another world. The auctioneer is there to sell at the highest price possible. Anything short of that would risk losing good customers, who were usually observing both the buyer and auctioneer at close range. If, in the farmer's judgment, the auctioneer knocked a pile of tobacco to a buyer at a price lower than another was willing to pay, he could always take his business to another warehouse. Since the auctioneer's commitment was to get the highest price for the farmer, he was bound to "take them buyers on, tooth and nail." To fall short of this goal would find him looking for another job for the next marketing season, or maybe before then.

There were cases, of course, when the auctioneer owned or shared a financial interest in the warehouse. This, of course, would mandate an even greater interest in high prices. One of the greatest factors, though, was the auctioneer's emotional commitment to prove to all that he was the best in the business and that no one could outdo him in keeping the price of tobacco high. In the mid 1940s, tobacco was selling in the thirty to forty-cents-per-pound range. Some grades were as low as ten and twenty cents a pound; some were as high as forty-five and fifty cents a pound, depending on the government grade placed on a pile by the United States Department of Agriculture (USDA) Tobacco Grading Service or the demand the buyers had for that grade.

> *Forty-two, two, two, detoodleoo, two three, ree, ree, ree, fo, fo, fo, fi, fi, sicky, sicky, semdesemebid, Liggett Myers; thirty-dollar bid, thirty, thirty, thirty, thirty, one, a one, two, two, anaree, ree, fo, fo, American. Twenty-fi, fi, -dollar bid, sic, a sic, sem, de eight a late, ate, ate, Run John* [R.J. Reynolds].

The auctioneer and the tobacco warehouseman had locked hands, hearts and commitments to their profession. In that huge wooden facility they were emotionally bonded together to an age-old ritual, which resulted in the success or failure of the tobacco farmer, one

of colonial America's economic and social foundations, and one who continued to hold that position.

The responsibility to his clientele was deeply ingrained, so much so that it became a second nature; first nature was the happenings at hand. The auctioneer knew what to do and was having fun doing it. He was in his element and in charge. He was aware that much depended on him at the moment, but after the sale was underway, nothing but his performance mattered. The rhythmic, staccato, machine-gun chant was ignited and there was no stopping him. He was the star and nobody could do the job like he could. Nobody could take his place and deal with the man across the tobacco row like he could. He was the product of a system of trial and

Dr. Hugh Kiger (right), one of the finest tobacco leaders of the twentieth century, is interviewed by Ray Wilkinson, farm news director for Capital Broadcasting, during the annual Tobacco Association of the United States meeting at the Greenbrier Hotel, White Sulpher Springs, West Virginia. Dr. Kiger, a retired marine colonel and USDA career man, stood out among all others as a tobacco leader. He was succeeded by J. Tommy Bunn, another tobacco leader who, unlike most of the others, came up through the ranks in the industry: first, the farm, and then the North Carolina Department of Agriculture, United States Department of Agriculture, and into the commercial side of the industry.

error that spanned over three centuries and had been revised, improved, proven and, for the most part, accepted by all those involved.

He was the tobacco auctioneer: an entertainer, in-house salesman for the tobacco farmer and the warehouse and the tobacco carnival barker who "brought 'em in" to sell their tobacco at the warehouse that would sell it for the highest price.

A Shocking Experience

By Bruce Woodard

One of the rewards the scaffold hands had if they worked fast handing and looping the tobacco was "catching up." That's when they finished a slide truck before another arrived from the field. Then everyone could sit down and rest a spell. Daddy tried to coordinate the work well enough to keep this from happening. He despised paying folks for sitting down. He would send word to the primers in the field to speed up because the scaffold hands were waiting for tobacco. This seemed to create a sort of contest between the two crews that always produced the results Daddy wanted.

Mary, Lila Mae and Betty were the buxom but very attractive daughters of Elm and Betsy Sawyer, sharecroppers on the Woodard farm during the 1940s. They were cute, jovial and very likable girls. They especially took pleasure in "catching up" and sitting down to rest. All three were pleasantly plump and welcomed the opportunity to take a load off their feet. Grandpa's old rocking chair sat next to the barn. At every opportunity the Sawyer girls raced to see who could get to it first. The chair was not only comfortable, but it was also wide enough to accommodate their broad behinds. Those not fortunate enough to get the rocker had to sit on the ground, the barn doorsill, a stick of wood or the empty slide truck.

My brothers and I were envious of the fact that we never seemed to be able to sit in the rocker. That's when we came up with a plan that would break the Sawyer girls from hogging the rocker. Earlier that year we had performed major surgery on our grandpa's old, junked, hand-cranked telephone. We had taken it apart and inside we found small copper wire about the size of horsehair. Little did we realize that the old telephone would later be worth a small fortune in antique value. We saved the wire figuring that it might be useful someday.

On Sunday afternoon Carl and I took the tiny wire to the barn. We wound it back and forth across the seat of the old rocking chair. Tobacco barning was to begin on Monday morning and we wanted the chair to

be ready for the Sawyer girls. After wiring the rocker we hooked a larger piece of insulated wire to wire in the bottom of the chair and ran it to the battery-powered electric fence at the pasture nearby. Now we were ready! The plan was to turn on the electricity before we finished stringing the first load of tobacco. Before all the leaves of the first truck of tobacco were out, Carl slipped around the barn and hooked the wire to the electric fence. Now the chair was charged with a healthy six volts.

As expected, just as soon as the last leaves of tobacco were out of the truck the Sawyer girls raced for the rocking chair. Mary, the oldest sister, got to the chair first and plopped down in it. When the first six-volt jolt hit her fanny she had a look of wide-eyed surprise. When the second jolt came moments later she screamed and jumped out of the chair, clearing the ground at least a foot! She ran about fifty steps toward the house in hysterics, since this had been her first introduction to electricity. By that time everyone was having a big laugh, especially me and Carl. Mary's expression changed from one of puzzlement and embarrassment to one of rage in just a few seconds. She recognized quickly that Carl and I were the villains. Using a few choice four-letter words she picked up a tobacco stick and came after us. She soon gave up the chase but promised to get us back for our prank later.

Daddy had a good laugh too, but chastised us for the disruption. We were told to disconnect the chair. But from that day on, when the scaffold help "caught up," the Woodard boys had little competition for the use of the rocking chair. After all, who knew whether it was "hooked up"?

I Tried to Kill Ray Jones

Ray and Roy Jones, twin sons of Mr. Garland and Miss Bessie Jones, moved to Huntsboro at the dawning of 1952, when I was twelve. They were almost thirteen and, for all our years together, their family raised tobacco on the Breedlove farm. Mr. Garland had a well-earned reputation of being one of the best tobacco farmers in the county.

Both Ray and Roy had bicycles. I had gotten my first one at Christmas. (It was a girl's bicycle, painted blue, and it looked suspiciously like one that had belonged to my sisters.) We immediately fused a tight friendship that transferred into an everlasting brotherhood. Even today, despite the fact that our adult lives have taken on separate paths, I consider those two boys, along with another neighborhood partner in crime, Michael Norwood, to be my everlasting brothers in spirit. The three were an integral part of my growing up.

Of the three, Ray had the greatest sense of humor. He was the very definition of a prankster and was hilariously funny. He would giggle incessantly at things that were just borderline funny, and he could make the rest of us giggle with him. Michael was simply a "trooper." Without a doubt, he was one of the nicest people I have ever known. Anything was OK with him. No matter what the situation was, no matter what stupid and reckless venture we concocted, Michael was game. It was almost as if he knew we were headed for needless trouble, but he kept close by just to make sure we had the advantage of his wisdom. He always looked on the positive side of things. While the rest of us were laden with childish attitudes tied to the dilemmas at hand, Michael seemed to covertly provide us with an adult-like protection. How I miss the joy of those days!

One of our most memorable events occurred one night when I "stole" Daddy's car and Ray, Roy, Michael and I went for a joy ride. It is important to note that Daddy was famous (maybe infamous) for his cars. To my

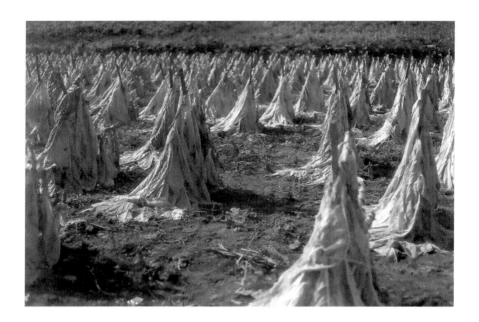

knowledge he never owned a new one, and the ones he bought, he ravaged. To most people, a car was something to be proud of, to wash and keep clean. The make, model, style and color usually were a mobile statement of pride to whoever the owner was. To Daddy, however, a car was nothing but a utility. Any car he bought had an automatic kiss of death put on it. You knew it was a matter of time before it was totally cluttered and ravaged. Each year I would beg him to buy a new car, but he always said he didn't like the models coming out for that year, so we had to wait until next year's model. It was just as well that he never bought a new car, though. As a matter of ritual, every car he ever had would be covered with dust from driving it across ditches and into a tobacco field, or from throwing a sack of cow feed across the hood and another across the trunk and then setting out for the pasture to feed the cows. In no more than a month after buying a new car, it would be so dusty that, if you thumped the headliner inside the car, the dust would choke you to death.

On many occasions, when he was ready to sell a small calf, he would take the backseat out of the car, run the calf into the back, get its head and neck to stick out the rear window on the other side and then roll up the window tightly under the calf's neck and take it to market. What made things worse was that he did this after I was old enough to drive and date. The livestock market sold cows and calves every Wednesday and my

dating nights included Wednesday nights. My early training in diplomacy came from explaining to my persnickety Wednesday night dates how that aroma got into the backseat of the car, and how, after all, it really didn't smell *that* bad.

It was easy to steal Daddy's car at night. He ran a country store where all the tobacco farmers gathered year-round to play "set-back," a popular card game of that era, and to talk tobacco, politics and various other critical issues of the day. He usually parked the car in the backyard of our house, behind the store, so he was oblivious to the danger of having unruly teenagers running loose. The only telltale sign that might give us thieves away would be if someone in the store happened to be watching the old primitive black-and-white TV set when we started the engine. If so, crazy-acting lines would appear on the screen and the audio would go into a screaming fit, sounding a lot like a skill saw. That would alert Daddy that someone had cranked up the car. Of course, the remedy for that was easy. We just loosened a tube and rendered the TV temporarily on the blink.

We didn't have drivers' licenses and couldn't get on the highway, so we had to drive around the tobacco fields behind the house. Since the car belonged to Daddy, the driving was left to me. And I was just beside myself with "show-off." How I could make that old 1950 Ford squeal tires, spin circles in the path and how I could "double-clutch" the gears! After wearing ourselves out with all the fun on the tobacco paths, I would cut the lights out and drove back through the barnyard and up behind the house, knowing that we had commandeered Daddy's car without a hitch and without getting caught and punished for stealing and ravaging. Wrong!

When I pulled to a stop at the hidden spot behind the house, there stood Daddy. His usual frame of five feet, eight inches became the Goliath of Huntsboro. When I looked up at him, I saw a man nine feet tall. He wasn't smiling. When Daddy looked at you and didn't smile, it would melt the ice cubes in a meat freezer. I was horrified, and rightly so. He wouldn't punish Ray, Roy or Michael, so all four whippings were cocked and aimed at one tender and boney butt: mine! As he reached for the door, Ray, not knowing Daddy was standing there and just how much trouble we were in, said in a loud and laughing voice, "Boy that was fun! But, it looks like Mr. Yeargin can't git a decent car and learn how to keep it clean. This dust is about to choke me to death. Next time we ought to drive it to Dexter."

As hard as he tried to maintain the composure of a mad executioner, Daddy's frozen face softened into a reluctant smile, then a chuckle and

finally, with his best effort at angered authority, he said, "Gimme them keys." I did. Then he slapped the living hell out of me. Since that night, we've told that story over and over again, no less than a million times.

Among the three of us, Roy was always the "wise" one. He had the answers for all the questions (at least he said so). It was true, however. I know because one of his most important jobs, outside of the tobacco field, was to help me with my homework. The truth is, I just turned it over to him, and Ray and I went about our business of acting stupid.

In addition to Roy's intellectual edge on me, he was well ahead of both Ray and me in physical development, too. It was out of this that the trouble started between Ray and me.

The fact is, Ray is lucky he made it to the age of drivers' licenses. During the warm months, whenever we weren't planting, plowing, suckering or priming tobacco, we all spent hours of ingenious creativity finding ways to amuse ourselves. Just out of being mischievous, many times late at night, we raided my uncle's watermelon patch. It didn't matter whether we were hungry. We would take the "loot" deep into the field, far down a tobacco row, bust it open and eat the better part of the "heart," or center, of the melon. As time passed, we felt it only expedient and practical that, instead of just dropping a melon on the ground, busting it open and eating only the heart, we should bring one of Mama's kitchen knives with us and do the proper thing: cut the melon open and eat not only the heart, but all the rest of it too. That made more sense to us.

On one foray, we had requisitioned an overripe melon from Uncle Clifford Hughes's patch and had meticulously cut it into several slices. We sat down on the railroad tracks, next to the watermelon patch, eating, giggling and enjoying ourselves, when suddenly we heard rustling in the bushes. The three of us reacted all at once and, in a flash, we disappeared down a tobacco row and emerged from the other side of the field and into the cover of the barnyard. We were safe again, but it was a close call. Like uncountable times before, we had pulled one over on Uncle Clifford Hughes.

That was late on a Sunday night. Early Monday morning, Uncle Clifford tapped on the back porch door of my house and called in to Mama, who was standing over the stove in the kitchen. "Virginia," he said, "them boys left one of your good knives in my patch last night."

As she retrieved the knife and apologized for our mischief, Uncle Clifford said, "'Peer lack to me thass one of yo better knives, Virginia. Why don't you git them one that don't cost so much, 'specially since they git in sech a hurry that they won't keep up with it?"

"Next year," she apologetically retorted, "I'm going to get Wilbur to plant a patch in our garden out yonder behind the strip house. Mebbe they'll leave your patch alone."

"I wouldn't do that," said Uncle Clifford, "that'll jess spoil all their fun."

When we decided to do Tom Sawyer kind of things, instead of walking on that thin line of adventurous legitimacy, we sometime sat up at the barns all night seeing to the curing of the tobacco. In those days, there were no automatic curing devices. We only used wood to cure tobacco, and that called for around-the-clock attention and tending to. Sometimes we would all get a cot or blanket and sleep all night at the barns. To us, that was a wonderful adventure. We loaded up our field and stream books, any kind of food necessary to keep us from having to sneak into Daddy's store during the night and then, while listening to the hoot owls, tree frogs, whippoorwills and dry flies, bedded ourselves down for a lot of fun and games in the night. Sometimes we would sleep under the barn shed, or sometime we slept on the hay under a shelter close to the barns.

Many Saturday nights the four of us, Ray, Roy, Michael and I, would camp out under the hay shed next to the tobacco barns at Ray and Roy's house. Most of the night we rambled around the barnyard, riding bicycles, wrestling in the hay, stoking the barn fires and keeping the temperatures right while the tobacco was curing.

But one night in the summer of 1952, I tried hard to kill Ray Jones! For the better part of two hours, I tried to kill him.

It started before daybreak one Sunday morning. We had been skinny-dipping most of the night in the pond.

At the age of twelve, going on thirteen, Roy Jones had begun to develop into manhood before Ray and me. That plunged the two of us into shameless competition. We each wanted to be the next to develop manly features, such as facial and underarm hair. Various other hair development was no less important to us either.

I remember it as if it was yesterday. I was caught up in the familiar fun of a farm boy's ritual of skinny-dipping, swimming around in the pond, minding my own business, when Ray called from the dam of the pond, "Hey Boogie-Son [that's what my Daddy called me and I hated it!] you gonna ever start shaving? My Mama made me shave yesdiddy."

Not to be outdone, I lied, "Course I've shaved. Mama made me shave before I went to Church last Sunday."

"That ain't nothing," he retorted. "I bet you don't have hair anywhere else."

I was ready for him. I had kept it a deep, dark secret, waiting for the right time to spring it on him and Michael and Roy. In fact, I did have a few newfound hairs in just the right places. I couldn't wait to emerge from the water, gather the two around me and say, "Here, look at it. I have now come into being as a teenager. Look at how I am growing hair in all the right places!"

I positioned myself and searched for the flashlight. I found it, but to no avail. The battery was dead. "Don't worry 'bout it," said Ray. "Lemme light this match."

He did, and thrust it toward the critical spot on my lower body. "Well, where is it?" he asked.

"Right here," I said.

"Where!?!?"

"There, damnit!"

In one smooth stroke, Ray thrust the lighted match toward the most strategic location—where the proud hair was. Without shame and remorse, he burned all three of those hairs off my body. All the progress I had made toward manhood was murdered by a match in the hands of a sneaky, jealous and unscrupulous son of a tobacco farmer, who was my greatest rival in the race for maturity.

I tried to kill him! For two hours, I tried to kill him. I tried to kill him with a tobacco stick, my pocketknife and a half-empty beer bottle I found in the grass. But I couldn't catch him. His legs were long and lanky and mine were short and stubby, so he outran me. I would have killed him if I could have caught him! The trauma of it all stunted my growth and started me to stuttering.

However, I must give him credit for not burning my flesh.

Which One Got the Girl?

One would be hard-pressed to write anything about tobacco farming that does not include soliloquies on the grueling heat, the backbreaking contortions and the energy-draining labor that all come with the package. Whether it's spring, summer or fall, or whether the time reflects the 1940s and 1950s, or 2006 and 2007, tobacco farming demands all the energy and commitment you've got.

In the early spring, tobacco demands undivided attention to the plant bed, the newly formed tobacco rows and the "just-right" dose of chemical application for a jump-start growth of plants. Late springtime demands the meticulous nurturing toward plant maturity. And the critical period of summertime, that step along the road to harvest, tests the tobacco farmer's tenacity. Here is, really, the toughest and most trial-ridden leg of the journey from tobacco seedbed to market. Summertime is when the tobacco farmer gets into the field and hunkers down to the job of getting the yellowing leaf off the stalk and into the barn.

In the old belt, we called it "priming" tobacco. Priming tobacco is hot and hateful. Priming tobacco means that you submit to the lowliest form of laborious servitude, the lowest rung on the social ladder. Furthermore, it is the very definition of degradation. When you are reduced to this slot in tobacco production, nothing eases the pain or passes the time any better than the lively and competitive bantering back and forth among tobacco primers about personal worth, conquests or advancement, or about any deed or feat that commands credibility. In short, those who served on the low end of the pecking order of barning tobacco, the primers in the field, were hopelessly caught up in personal bragging rights.

When it came to personal conquests with "wimmen," each needed desperately to "lord" over the other. Short of being the best in the field as far as success with "wimmen" was concerned was to admit to being less

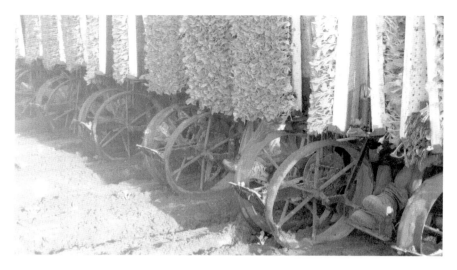

Planting seedbeds.

than what "yo' Daddy" brought you into this world for. Among all the others in Wilbur Yeargin's tobacco field who spun their "wild and woolly claims to conquests," were two tobacco primers who come to mind, namely, James Bryant and Al V. "Skeeter" Hawkins. Both were tall, lean and lanky. Skeeter lived on the isolated "John Brooks" place, way back in the middle of the pasture, away from it all. He liked the isolation. It reduced the chances of his getting caught making "white" (moonshine) whiskey. And James, who lived in the more upscale log house on the farm, close to the road, was, of the two, the more virtuous.

Compared to Skeeter, James was a saint. He was an active and contributing member of Mount Zion African Methodist Episcopal (AME) Church, just up the road toward Carl O'Brien's store. Both were in love with a lady we'll call Gobelia. Both claimed courting rights to Gobelia. Between priming large armfuls of green tobacco leaves and tossing them over into the tobacco slide, they would argue back and forth as both went to great and exaggerated lengths to make their respective cases on those rights. The truth is, once all the work was done in the barnyard, Gobelia was the final judge on which of these cavaliers she would accept into her boudoir for the weekend. She hinged her decision on the accomplishment of the greatest of all feats: who could first get to her door with a full carton of Pepsi-Colas and a mess of turnip greens. That was the deciding factor. But it wasn't as easy as it seemed.

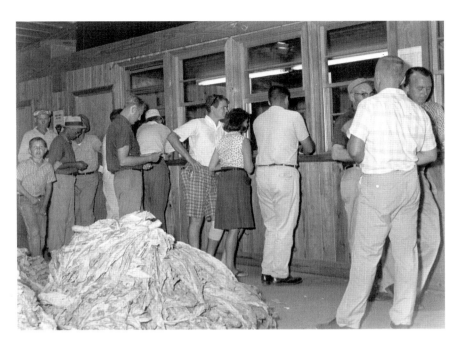

Joy comes at the end of a hard year's work. North Carolina Tobacco farmers gather around a pay window at a Boarder Belt Tobacco Warehouse waiting for the year's first big check.

Success came to the one of the two who could finish up their respective jobs in the field, as well as the barnyard. Whoever could covertly sneak out of the field, get to the barn, "heist" the tobacco, get to the store and get paid, then fetch up a carton of Pepsis and head to Gobelia's house down next to the woods with that carton of drinks and a sack of turnip greens before the other knew what was happening had dibs on Gobelia for the weekend. What a contest!

One Saturday, just before the dinner bell rang, Skeeter Hawkins finished his row and bent over double so he couldn't be seen as he slithered his way toward the barns. He pulled two handers and a stringer from one of the stringing racks and proceeded to "heist" all the tobacco. In no time flat, the job was done. Then Skeeter headed to the store for his pay. He bought the carton of drinks and the mess of turnip greens and headed for Gobelia's shanty house down by the woods. As he sauntered down the path, James Bryant stood on the top of a tobacco row and watched. Seething with fierce anger, James knitted together a scheme to bring balance to Skeeter's game.

James finished up in the field, brought all the other primers to the barn and finished filling the empty rooms with the remainder of tobacco. He took his time sauntering up to the "sto," getting his weekly pay and asking "Mr. Wilbur" for a good-sized paper grocery sack. From there he headed to the harness room at the stable, where he knew about a softball-sized wasps' nest hanging back in a far corner. Creeping into the harness room, James slowly and carefully thrust the mouth of the paper sack around the wasp nest. With his forefinger and thumb, he squeezed the mouth of the bag around the wasps' nest and then pinched the nest away from the nail that held it onto the structure of the harness room. When the nest fell into the sack, James closed the top around the sack and the already swarming wasps. He folded the top of the bag and turned toward Gobelia's house on the edge of the woods.

James was no stranger to Gobelia's house. He knew all about it. He knew where all the cracks were in the walls. He knew where all the beds were in each room; and he knew which one Gobelia tended to favor for recreational purposes. He knew which screen window Gobelia's little boys peed out of when they answered their midnight nature calls. He also knew the effects saltwater had on the metal screenwire. He knew salt would make screenwire rust out. And being the scientific genius he was, James surmised that, since the screen was rusted out in certain places, it made sense that he could punch out a good-sized hole where the rust was most advanced. He did. Then he stuck the mouth of the wasp-filled paper sack into the hole, all the way into the inside of the house, tilted it upward, heartily thumped the bottom of the bag two or three times and just let gravity and wasp pandemonium take over.

Suddenly, that nine-hundred-square-foot bungalow was saturated with about two thousand square feet of mad wasps. Just as Gobelia and Skeeter had reached the point of ecstasy, the wasps had reached their boiling points. Their weapons of war, however, set about reducing the ecstasy of the embraced lovers to horror, pain and panic. Skeeter had won the battle, but James Bryant had won the war. His victory lasted much longer than did Skeeter's conquest. James went on to marry Miss Gobelia and lived happily ever after, producing three of the finest children I ever knew.

Mules and Memories

By Burt Kornegay

"I reckon we'll farm as long as we're able. We've got so poor we cain't do nothing but farm!"

Bulk barns, automatic harvesters, leaf stitchers? These are integral to tobacco farming today. But just thirty years ago most farmers would have thought they were words from a foreign language! Mules, plows, pegs and sweat were what they knew: direct, one-syllable words. If you had asked to see their machinery, chances are they would have held forth their own two hands.

Tobacco is still America's largest cash crop that is most dependent on the human hand. Almost three hundred hours of labor must be put into the cultivation and marketing of every acre. In comparison, it now takes no more than four hours to farm an acre of wheat! Of all tobacco, bright leaf has been the most receptive to mechanization. Yet, as late as 1960, the farming of it had changed little since the previous century. Even today, the suckering, topping, cropping and hanging of that crop remain a vital work heritage.

Thirty years ago, however, no one would have thought of calling any aspect of tobacco farming a "work heritage." It was all just work! And there was enough of it for everyone to have as much as they wanted, and then some.

Maybe that's why tobacco farmers like their mules. Maybe that's the reason they talk about old Doll and Della and Mag and Kate with such a fond tone. Of course, when they actually owned Doll or Della, the farmers probably didn't have much more to say about them than a

Tractors, like this old McCormick, brought in a new age in farming. They hastened the demise of the mule in the fields of North Carolina while bringing about much-needed efficiency in tobacco production and harvesting. The appearance of this tractor, ridden here by future North Carolina Governor James B. Hunt Jr. while James B. Hunt Sr. pours water in the radiator, enabled farmers to cover much more farmland in a shorter time than did the ancient mule.

couple of brief, earthy epithets that are best not mentioned. However, even then they knew that those long-eared, sure-footed, eleven hundred ornery pounds of pulling power could turn the ground with a plow like no earthly man!

It was not uncommon for a mule to live twenty-five years. That mule would become like a member of the farmer's family. The farmer had to feed his mule in the morning before he ate breakfast himself, and feed it again at night before he took off his boots and stretched his aching toes to the fire. When the mule got sick there was doctoring to do. When either the mule or the farmer woke up in a bad mood, a fight was sure to follow before bedtime came around. And, whether he liked it or not, that mule's hind end was the farmer's primary scenery for a considerable portion of each day.

When the tractor came along in the late 1940s, it seemed like the world had suddenly changed—many farmers felt for the worse. But they had

to admit that a man and a mule could plow no more than two acres of ground in a day, while a man with a tractor could plow three or four acres every hour! That was the difference. And to farmers with families to feed and hopes for some material betterment in life, the choice was obviously in favor of the mule on wheels.

Tractors, like the old McCormick, brought in a new age in farming. It hastened the demise of the mule in the fields of North Carolina while at the same time bringing about much-needed efficiency in tobacco production and harvesting. The appearance of the tractor in the accompanying photograph, ridden by future North Carolina Governor James B. Hunt Jr. while James B. Hunt Sr. pours water in the radiator, enabled farmers to cover much more farmland in a shorter time than did the ancient mule.

Old-timers rarely look back on any aspect of their pretractor farming years without emotion. Many tend to see the bright side of that life. They recall such rural pleasures as skinny-dipping in a "black-water" creek and warehouse dances at the end of the market season that have now all but disappeared from the land. Others shake their heads, tighten their jaws and talk in hard, uncompromising terms. They remember the thirst and sweat of the field, the day-after-day necessity to labor as if life itself depended on it—which, in many cases, it did.

The truth about the past includes both of these memories and all that lies between the two extremes. Maybe for some, life was more enjoyable or more difficult than for others. With many farmers, it is not only their words, but also the weathering of the faces that express for the nation a largely untold and almost forgotten story.

Reprinted with permission.

Santa Claus Died

One of the first real tragedies in my memory was the death of Santa Claus. Santa Claus was really old. I don't know how old, but he was old enough that I sensed my Daddy and our sharecropper Roger Hunt, who maintained a close working relationship with him, thought it was a merciful act of God that Santa died when he did.

I remember that we were eating supper and it was dark, so it must have been in the winter, when there came a tap on the back porch screen door.

"Wonder who that is," said Daddy, as he wheeled around in his chair.

"Missa Wilbur," came a voice through the porch screen. "I needs to see you a minute."

"Izzat you, Roger?"

"Yessah. Can you come out cheer for a minute?"

By that time, Daddy was standing on the steps. "What's wrong?" he asked.

"Missa Wilbur, Santa Claus has done died."

"What?" said Daddy. "I jist saw him 'fore dark the day 'fore yesdiddy and he looked alright to me!"

"I reckon he did," said Roger, "but he ain't alright now. He's dead and the buzzards is already started on him."

With this, we all streamed out of the kitchen and off the porch, one behind the other, like ducklings following their mother to water. Off we went, following Daddy and Roger, who had lit the lantern and held it up as he walked so we all could see and would not stumble over one another and the tree roots by the smokehouse. Down by the stable we went and along a narrow, well-worn "spring path" cut out by the cows and mules as they ambled back and forth to the watering hole at the bottom of the hill. Sure enough, there by the branch lay Santa Claus.

It was there that I first learned how buzzards prioritized the delicacies of their divinely delivered carcasses. Santa's eyes and rectum had been

the first to go. I guess there must be a bit of irony to their method. At least, on the one end, Santa couldn't see what was happening to him. We all stood for a while and gazed through our tears at the lifeless body of Santa Claus. I don't remember why the others were crying, but I clearly remember that, aside from being a small child and suffering from the trauma of the death of anything named Santa Claus, I was crying because Santa Claus was the most gentle mule I had ever known. (It didn't matter that he was one of only three that I had ever known.) When he wasn't pulling the plow for Roger, Santa Claus would stand perfectly still and let me sit on the ground under him and lean back to rest upon the inside of his hind feet. He would not move! He would also stand perfectly still while Daddy perched me on his back and, without a bridle, would take him by his short mane and lead him around. Or, as Daddy busied himself with nearby chores, he just let me sit there on top of Santa and enjoy.

Santa Claus, the mule, represented kindness and goodness, patience and tolerance and the air of giving—giving pleasure to a little boy whose understanding of life, at the ripe old age of five, went only so far as to seek the simple excitement of a relationship with a huge beast that would yield to his whims. That's all I knew about Santa Claus. And that's all I needed to know. Santa had cast himself in the role of making lifetime memories for a little boy.

Roger knew Santa Claus better, though. He knew what a good plowing mule he had been. I had heard him say so. I had heard him say that there was no better mule in the county when it came to laying tobacco by and "busting" the middles in the rows of tobacco. Many times he would wind the plow lines around the harness and, without tangible control, talk Santa Claus into and out of the tobacco rows. And I guess that is why Roger, his wife Nora, their son Mark and daughters Mabelee, Adale, Lula and Annie all huddled together with us as we cried over Santa Claus's departure.

After a while, Daddy announced that surely Santa was much older than he thought, so it must have been time for him to die. With that, he and Roger began piling various-sized limbs and debris on top of the lifeless corpse. When Santa was no longer visible underneath it all, they struck a match and soon there was nothing left of old Santa Claus; that is, except his memory—his pristine memory that holds a warm place in the storehouse of my life.

A Rich Family Heritage

By Wilson Crabtree

During the early Depression years farmers carried their tobacco to market on horse-drawn wagons. This would require them to stay one night and to be away from home for two or more days, depending on how far away they lived from the warehouse. On this occasion, farmers' wives would pack them enough food in a box or basket to take care of their needs until they returned home. During this time the wives, with the help of the children, would be preparing another load of tobacco for market.

Sometimes the farmers would bring back a half bushel of apples if they felt they could spare the money. This was a real treat for the children because they only received extras like this at selling-tobacco time and at Christmas. The other goodies they had during the year were things that their mothers could prepare in the kitchen; namely, popcorn, homemade candy and cookies.

As the families grew and the prices of tobacco increased just a little the farmers would go to the shed and get out the family car, which had been parked for some three or four years, and get it in a condition for use. It had been parked because there was no money to buy the license tags and gas to operate it.

With the availability of the car for transportation, farmers found another use for the car. They would find a neighbor with a farm trailer (built from either the front or rear end of an old, junked car), load the tobacco on the trailer and go to market.

In order for farmers to get top dollar for their tobacco, wives would carry live turkeys they had raised on the farm. The warehouse employee running the sale would announce that the buyer who purchased the

Above and next page: A tobacco load is delivered in the late evening. Farmers bed down for the night waiting for tomorrow's first sale.

largest number of baskets of their husbands' tobacco would also get a turkey. The wives always received top dollar for their husbands' tobacco.

After the sale, and after the check was cashed, wives would take the children shopping for their school and winter clothes and whatever school supplies they needed. If there was enough money left after those purchases, they would buy something for themselves.

When farmers carried the last load of tobacco to market before Christmas their wives would go with them and, after the tobacco was sold and the check cashed, the parents would shop for the children's Christmas gifts. This would be the last time the wives would accompany their husbands to market. They most likely would not go to town any more until the spring, when it became necessary to buy more clothes for the children.

During those Depression years it was not all gloom and hard work. Parents put forth a tremendous effort to provide a good healthy environment for their children, to try to compensate for the hardships that they were experiencing.

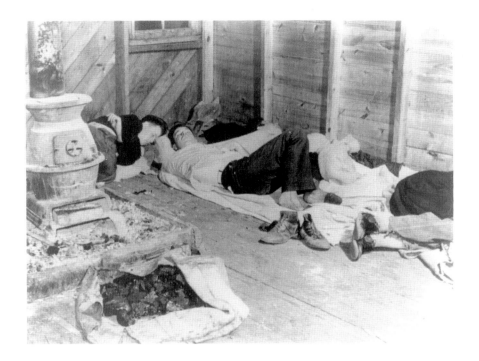

During the summer months, usually on the Fourth of July, the community would have a fish fry down on the river or creek. The men in the community provided the fish by seining the rivers and creek. The wives would cook the corn bread at home and would carry that, along with desserts (usually apple and peach cobblers), with the fruit coming from their own orchards. While the fish were being fried the children would either wade in the shallow water or swim in the deeper water. Lemonade was the beverage of choice.

The churches in the community would sponsor a Sunday school ice cream supper. The ladies would prepare food at home to carry and this food was spread on a big table (covered-dish style). These picnics were held at a public park in town. Churches would also have homecoming day and, again, the food was spread covered-dish style on the long table.

If the farmers in the community had a good crop of watermelons they would all give some of their crop, and another family in the community would sponsor a watermelon slicing at their home. The young people from the churches in the community and schools, and kinfolk from town, were invited and they had a good time.

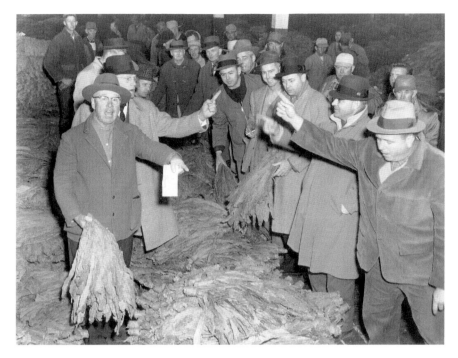

There was a time when tobacco sales demanded that the participants don their best in dress. These buyers, farmers and warehousemen, who are dressed in Sunday attire, provide the proof.

Another thing that was truly enjoyed not only by the teenagers, but also by the small children and adults, was an ice cream supper. The young people would invite their friends from church and from the schools they attended and these parties usually ended up with games that were enjoyed by the young people.

When the last of the tobacco crop had been harvested and was being cured, one family in the community would decide to cook a Brunswick stew at the barn. The wives would get together and decide what each could furnish from their vegetable garden. Some had onions, others potatoes, some corn, some tomatoes and others would bring butter beans and chickens for the meat. The men would help out by killing several squirrels for more meat and a little added flavor. This food was prepared and cooked together in a big black pot.

When it was ready to be served the neighbors came to eat and have fellowship together. The farmer that was hosting the meal would have a long trailer or a long bale of hay from his wagon and this was used as a table.

During the winter months different families in the community would open up their homes for a square dance. On other occasions they would have candy pullings in different homes. The ladies would get together in the winter or early spring for a quilting bee.

The men were not left out of things that appealed to them. They would organize a group of the neighbors and hunt wild game. Of course, on some occasions they would probably tell a few lies about who had the best coon dog or whose bird dog could find the largest covey of quail. They would also brag about who had the best gun or who was the best marksman in a turkey-shoot competition. These events were usually held near Thanksgiving and Christmas.

As you can see the parents were doing every thing they could to give their children some entertainment and doing so with a very little expense.

It was during those depressed years that the only contact the young people had with the outside world was through their friends at the local churches and schools. There was very little migration from the farm into the city because there were no jobs available there.

Therefore, the young men in the community stayed on the farm and took wives they had probably met at one of those social functions in the community. The wives, too, were probably daughters of the farmers.

In most cases newlyweds would settle down on one of their families' farms and raise a family, continuing the tradition that had been such an integral part of their lives. This condition continues today, and often that same old family farm has been owned by the third and fourth generations of their ancestors. They consider this a rich family heritage and they have no desire for it to change on their watch.

Reprinted with permission.

As I Look Back

BY WILSON CRABTREE

Before the stock market crash in 1929 the average tobacco farmer was not getting rich, but was enjoying the good life. He was able to buy a new car as the need arose. He kept good young mules and horses to farm with, and he put his children through high school and, those who desired, through collage. His wife stayed in the home, cared for the children and ran the home. Sometimes, if the farmer made a good crop and it sold well, he would purchase another small farm or a small tract of land. The acquisition would enable him to increase his farming operations as his family grew.

Since tobacco required more labor than any of his other crops he would hire one farmhand full time for the entire year. He would provide him with a place to stay, usually a small cabin on the farm, and he would eat three meals a day at the farmer's own table. Then, when harvest time came and more labor was needed, he would hire more labor and would keep them until the crop was in the house. During this time the older children were helping in the fields and at the barns, doing the work that they were capable of performing.

However, this all changed with the beginning of the Great Depression, which came on as a result of the stock market crash and would last for the next ten years. The roles of the farmer's wife and his children were greatly changed at this time. This change was caused by the farmer's inability to afford hired labor to do all of the work. It became necessary for the wife and children go to the fields and work alongside their husband/father on any jobs that they were capable of performing.

The husband's lack of money to hire labor came about because of the sudden drop in the price of tobacco, sometimes to as low as five cents per pound.

The wives, and daughters who were old enough to work, accepted this new role in their lives because it was becoming a necessary way of life for tobacco farm families.

Wives and children helped in all stages of the tobacco crop production with the exception of breaking the land and preparing it for planting. Preparing the land was strictly a job for the men and teenage boys.

There were times when an older teenage girl was called on to help with a job that the mother would consider too strenuous. The mother then would take the place of the daughter in the field. The daughter would be sent to the house to cook and/or look after the younger children. This would occur often.

As time went on and the lack of money became more serious, some families would make more drastic changes to their lifestyles. Teenage boys would drop out of school to stay on the farm and work. There were several girls in the rural school that my family attended who had to stay home and work. These girls would get behind in their schoolwork, lose interest in school and would eventually dropout and never graduate.

To help alleviate this problem and to encourage older children to stay in school, the county board of education instructed the schools to hold classes for only half a day for the first two to three weeks of the school year. This policy would help the farm labor situation and would improve school attendance.

Some families had several boys large enough to do more men's work. On occasion, the health of the father had declined to the extent that he could no longer work. With the permission of the parents one boy would stay home and work while his brother(s) would go to school for the entire year. The following school year the brothers would switch and the other boy would go to school. They both eventually would graduate.

Most farm families with a limited amount of labor would find another farm family in the community with a small labor force and they would exchange work with each other. This practice helped solve some of the farm families' labor problems during the season of housing tobacco. The housing of tobacco and preparing the crop for market were the two seasons of the year when the farmer would benefit the most from his family's labor.

The wife and children, along with the neighbor's family, practically took care of getting the tobacco from the field to the barn, the handling of the leaves and the looping of the leaves on tobacco sticks for curing. The adult men would pull or prime the tobacco in the field and, when

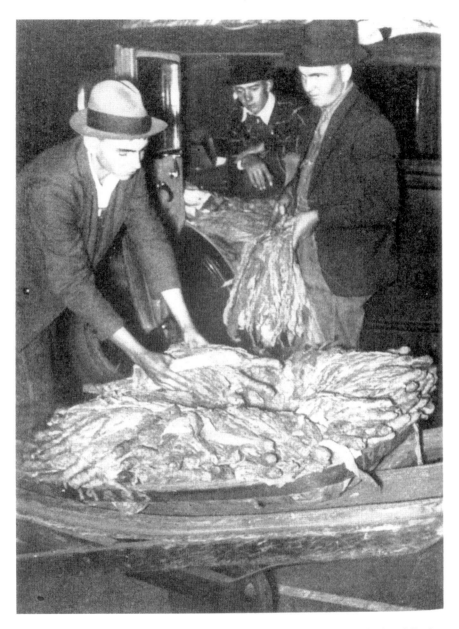

Farmers taking time, as they wait for the buyers, to dress the tobacco basket full of tobacco.

they came to the barn at noon for lunch, the only task they had to perform was to hang the sticks of tobacco that had been looped by the wives and children.

The curing process would begin next. The length of curing time of the tobacco in the barn depended on several factors: namely, the moisture content of the tobacco when it was placed in the barn and the outside weather conditions. It usually required about four to five days to cure. The heat would be started between 90 and 100 degrees. This would begin the yellowing process on the very tips of the leaves. The heat slowly would be increased from 100 degrees to 110 for several hours, then it would slowly reach 120 degrees and remain at that point for several hours or until the leaves were reaching the desired color. At this point the leaves continued to yellow and were beginning to dry on the very tips.

No two barns of tobacco would cure the same; some cured faster and some slower. The farmer would have to use his experience from past years to determine when the tobacco was yellow or dry enough to increase the heat. Most of the yellowing would be completed after the heat had been kept at 140 degrees for several hours.

Next came the killing-out process. The heat was gradually increased to 160 degrees for several hours, then to 170 for a few hours and then 180 until the stems were all completely dry. Sometimes this required several hours at the same temperature. If the stems were not completely dry the tobacco would mold and rot when packed in the packinghouse.

When the stems were completely dry the lines were pulled from the flues and the doors to the barn were opened after the barn had cooled down a little. If the barn of tobacco was filled on Monday and the fires started late that afternoon, the process was likely completed on Tuesday afternoon. By leaving the barn doors open through Friday night, the barn would receive enough moisture during the night that the tobacco could be taken out by Saturday morning and placed in the packinghouse.

The curing process required a lot of the farmer's time because he would have to keep a watch on the barn and its contents both day and night to be sure the proper temperature was maintained throughout the process.

The farmer's wife would also help in the curing process if the farmer had to be away for a few hours. The curing process required a lot of know-how, which the wife soon learned from her husband. Occasionally the wife would take over the process and supervise the curing of the tobacco in the event of sickness and/or other emergencies that would keep her husband away.

These tobacco sticks provided many essential uses for the tobacco farmer and his family. Of course, the primary use of the tobacco stick is for the looper to hang approximately thirty-two bundles of tobacco leaves across it to be hung in the barn on the tier poles as it is being cured. Often the farmer's wife would stack the tobacco sticks to form a chicken coop to hold the mother hen and new biddies. Most importantly, though, a tobacco stick served as a horse for the children who played around the barn during barning time and tobacco stripping time.

After all of the tobacco was cured, which was usually an eight- to twelve-week process, the next step was to prepare the tobacco for market. This process consisted of adding the proper amount of moisture to the tobacco. This was achieved by hanging the sticks of tobacco on tier poles in the ordering pit. The next morning the tobacco would have accumulated enough moisture that you could take the leaves off of the sticks and place them on the grading bench. Children would often complete the task of removing the tobacco from the sticks for about thirty to sixty minutes just prior to going to school in the mornings. This amount of tobacco each morning would give the grader, usually the husband, enough leaves to grade until his wife could cook their lunch and then join him in the stripping room. He would continue to grade and then the wife would remove the tobacco from the sticks and place it on the grading bench. She

would also tie bundles of the tobacco that had been graded. There were typically four or five grades, and after the tobacco was tied it was hung on sticks ready for market. Each grade had to remain separate, even after it arrived at the warehouse. The husband and wife would continue this process each day until the crop was ready for market.

After school the children would join their parents in the stripping room and work until suppertime. After supper the family would return to the stripping room and continue to tie graded tobacco into bundles and hang it on sticks. The children would then complete their homework for the next day. This process would continue from about the first of October until late December or early January.

The production, harvesting, curing and marketing of tobacco was more than just a "man's job"; the job was bigger than any one man could accomplish. It was truly a "family affair." Women and children played vital roles in the entire process. Their contribution to tobacco production was an integral part of the crop's rich history and the impact it had on the local, state and national economy.

Reprinted with permission.

I Remember

By Sandra Broome

Ira Stanphil once wrote a beautiful old song, tailored especially to the memories of folks in the South. In part, it read: "Some of the fondest memories of my childhood were woven around suppertime, when, from the back porch steps of my home-place, my mother would call: 'Come on home now, son. It's suppertime.'"

How vividly I can remember hearing the sweet tenor ring of my mother's voice as she repeated those words every summer afternoon as I steadied a mule-drawn plow between the rows of green tobacco. And how serene and rested my soul felt, knowing that her call summoned me to a safe and love-filled farm home where character, patience and endurance were instilled into me through example. In the writing of Sandra Broome's recollections, entitled "I Remember," the elements of a life of quality can be gleaned.

THE BEAUTY OF A BARN

Having grown up on a tobacco farm, barns were very much a part of my childhood, and for good reason. I have always associated them with hard work. My initiation into working around barns came at an early age. I can remember quite vividly the summer before I entered fourth grade because that was the summer Daddy decided I was old enough to start working at the barn. Needless to say, I was not happy with his decision, and even though I knew tears would not get me out of my newly assigned responsibility, I tearfully explained to him that I just wasn't cut out for farm work. He listened but never commented, and the next morning at 6:00 a.m. I found myself sitting wearily beside him on the front seat of his old pickup truck.

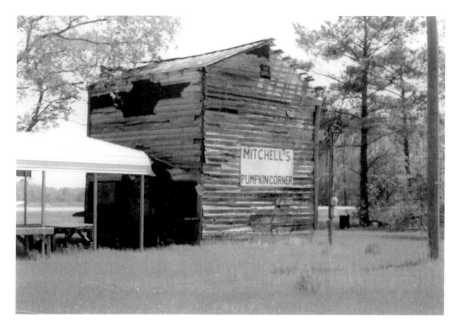

Through her talents, Sandra Broome has painted a wonderful and nostalgic illustration of life on the farm. This old tobacco barn, perhaps erected in the early twentieth century, holds countless memories of young children in the process of growing up. No doubt, it has been the subject of much twenty-first-century "supper table" reminiscing. *Picture courtesy of Sandra Broome.*

It was the first day of the tobacco barning season, and we were headed down to one of the tobacco fields. I worked for Daddy every summer after that until the summer before I graduated from high school in 1972. I made a promise to myself that last summer that I would never touch another leaf of tobacco again for the rest of my life and I have kept my promise.

MY BIG DILEMMA

Daddy allowed his barn and field hands a fifteen-minute break in the morning around ten o'clock and in the afternoon around three o'clock. For our snack, we could choose a pack of peanut butter nabs or a honey bun to go along with our ice-cold Pepsi-Colas. Probably the biggest dilemma of my day was trying to choose between the two snacks. I knew

The "skirt" (covered top) around this barn is indicative of the types built in the Eastern (tobacco) Belt of North Carolina. This belt ran from about present-day Interstate 95 eastward to the coast and from Rocky Mount to Clinton. Aside from serving as shade for those stringing (or tying) the leaves, the "skirt" was sometimes fitted with two-by-four planks, spaced so that tobacco already strung and not ready to hang in the barn could be held until it could be hoisted (or, in local vernacular, "heisted") onto the tier poles inside. *Picture courtesy of Sandra Broome.*

if I picked the nabs, which came in a pack of six, I could eat three and squirrel the other three away for later, but if I chose the honey bun there was no way I would be able to save any to enjoy later. Those sweet buns covered in a light honey glaze were so good I would always eat the whole thing at one time. Denise and I finally figured out a way we could have the best of both worlds. I would get a honey bun and she would get a pack of nabs, and we could split the two between us. It's amazing how important those little pleasures in life seemed back then. I am just thankful I did not know the real dilemma my parents faced every day of trying to make a living on a small family farm.

A roadside packinghouse where tobacco was kept, and many times graded and tied, before being loaded and taken to town for sale. Having a packinghouse close to the road served to better expedite ease for getting on the farm-to-market road. *Picture courtesy of Sandra Broome.*

Walking on Eggshells

Daddy was especially short-tempered, tired and irritable during the tobacco barning season. Mama would oftentimes try to smooth things over for Denise, Renee and me and was quick to point out to him that we were, after all, children. He would come home every day well after dark and begin every morning in the dark, especially when there was a barn of tobacco to be taken out and moved to the packinghouse for grading. This was done around 5:00 a.m. or earlier in order to ensure that a barn would be empty and available for the new day's barning. I was always so happy when this time of year was over. If I had understood how hard it was to make even a meager living at farming, maybe I could have understood his moods better, but while I didn't realize it at the time, mine was indeed a case of "ignorance is bliss."

Big Planters Warehouse

In the fall, when Daddy worked at Big Planters as a tobacco weigher, Mama, Denise, Renee and I would often take his supper to him in the

Second-generation tobacco auctioneer Edward Stephenson and staffer Billy Yeargin share a laugh just before first sale on a September morning in 1998 at Bright-Leaf Riverside Tobacco Warehouse, Smithfield, North Carolina.

evenings. There was a certain air of excitement about the warehouse, sort of a carnival- or fair-like atmosphere, and I thought it was very exciting. When the fast-talking auctioneers were auctioning off the tobacco, I never knew how anyone could understand what they were saying. However, by the time the buyers and the farmers walked in unison behind him to the end of a row of sheeted-up tobacco, the product was sold to the highest bidder. I was fascinated by the whole process and loved going to the warehouse.

BOOTS, POPCORN AND THE JONES GIRLS

Over the years, Daddy had some very good farmworkers. For several years, he went to Virginia and brought back young, black migrant workers to work as field hands. They had funny nicknames, such as "Boot" and "Popcorn," and since I was a child at the time their names really appealed to me.

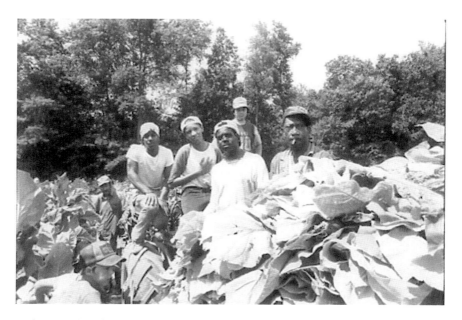

To be sure, these hardworking tobacco primers are looking to the cameraman to hurry up and finish with the picture so they can take a break for a cold drink of water or cola.

They stayed in what we called the "Bessie House"; another one of Granddaddy's tenant houses where Daddy, Mama and I lived for the first three years of my life. The house had fallen into disrepair and had no inside bathroom or underpinning. I remember thinking that they must need the money pretty badly to be willing to live in the Bessie House.

There was also an older, married black couple named Handy and Laura who worked on the farm. At one time, the house they lived in was located across the road from Granddaddy and Mama Gurley's house, but sometime through the years the house was moved down the dirt path beside my grandparents' home and set up beside the pond.

Miss Laura was a frail and sickly little woman. In the hot summertime, I remember that she would wear a hat, a dress over long pants, a long-sleeved shirt and a jacket. I could not believe anyone could be that cold natured. When she died, our family paid our respects at the wake, which was held at Walter Sanders Funeral Home in Smithfield.

Another woman who comes to mind is a short, stocky, hardworking black woman named Dorothy. Every Fourth of July we spent the day freezing corn, and one year she came to our house to help us. We cut most of the corn off the cob so this was an all-day undertaking. That day

around noon Mama went inside and made sloppy Joes and sweet iced tea for our lunch. As we all sat around the bar in our kitchen, I remember thinking how strange it was that we had a black person actually eating in our kitchen, not to mention the fact that she was eating off of one of our plates and drinking from one of our glasses. I don't believe that we were particularly prejudiced, because we like Dorothy very much. Segregation was just a way of life and a common, accepted mindset in the South during this time.

A white family, the Joneses, also helped us for years. The family had one son, Buddy, and seven daughters—Dorothy, Edna, Teresa, Betty, Carol Ann, Rosabelle and Sheila Ann. They were very smart workers, and Daddy relied on them to work at the barn during the tobacco harvesting season.

If Daddy and Mama had not been able to find good people to work with them, supporting our family would have been even harder that it was. I don't know how they managed to make ends meet with Daddy farming and Mama working at Fieldcrest Mills, but they provided Denise, Renee and me with a loving, nurturing home life, and we always had what we needed. We were very blessed.

PUTTIN' IN

The process of putting in a barn of tobacco was a hot, backbreaking job and one that was repeated many times over during the barning season. The season began in mid- to late June and finished up around the end of August. Due to the unyielding heat, the field hands, or "croppers," would start their work as early in the day as possible. Also, this ensured that a trailer of tobacco would be waiting for the barn help when they arrived around 7:00 a.m. Time was money to Daddy, and he made sure none of us had time to sit or stand idly around the barn or at the end of a row of tobacco.

In the field, the croppers would begin by pulling the leaves from the bottom of the stalk and work their way up a little higher with each barning. The first leaves were called "sand lugs." These leaves were usually yellow in color with dark spots, and they got their name because they were at the very bottom of the stalk and often covered in dirt or sand. After the first cropping, workers were careful to pull only the ripest, greenest leaves. They would pile huge armloads of tobacco into a tractor-pulled trailer,

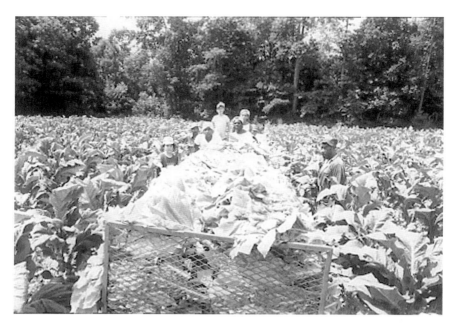

Tobacco harvesting, or in local vernacular "barning," "priming," "filling barns" or "putting in tobacco," was, without fail, a backbreaking job. These tender-footed "tobacco primers," who have been thrust into the scorching heat of a tobacco field for the first time in their lives, will attest to that.

or "truck," which was then driven to the barn. I often wondered how the croppers could bend over to reach the leaves while they carried a pile of tobacco under the other arm. It was truly a backbreaking job.

At the barn, workers would stand around the truck, gather small bundles of tobacco and hand them to the "stringer." The stringer stood behind a wooden-framed stand or "horse" and used thick tobacco twine to tie the bundles of tobacco onto a wooden stick. The heavy sticks of tobacco were then handed up to a person who was perched on tier poles inside the barn. These poles started about head high and ran all the way up to the top of the barn; balancing oneself on these poles was no easy task. I can recall several times when a person lost his balance and fell onto the dirt floor of the barn. It was hot, dirty work, but compared to the croppers, people at the barn usually had the advantage of working underneath the shade of a barn shelter.

First thing in the morning, the freshly cropped tobacco was still wet from the early morning dew and always sticky with tobacco gum. If you

have ever handled tobacco, you know how hard it is to get the gum off your hands and fingernails. In an effort to stay dry, I always wrapped a piece of thick plastic around me, which extended from my armpits down to my ankles and secured it around my waist with tobacco twine. Unfortunately, as the day grew hotter, so did the plastic, but I still thought it was better than getting wet and sticky first thing in the morning.

The croppers loved to surprise the barn help by hiding a dead snake underneath the densely piled tobacco leaves in the truck. We never knew it was there until one of us had the misfortune of grabbing it instead of the tobacco. It made no difference to me if it was dead. As far as I was concerned, dead or alive a snake was a snake, and I would always scream my head off at the sight of one. They were often found tightly curled around the bottom of a tobacco stalk or in the corner of a dark, dank barn, probably seeking a shady respite from the terrible heat. Snakes were just another one of the realities of working in a tobacco field or around a barn, but I never seemed to get used to seeing them and still carry a terrible phobia of snakes with me today.

Making last-minute shifts in piles of tobacco, getting them ready for sale at the old Roy Pearce Tobacco Warehouse, later known as the Bright-Leaf Tobacco Warehouse in Smithfield, North Carolina, circa August 1995.

The Aroma of Flue-Cured Tobacco

Once a barn was full of green tobacco, the curing process began, and if I close my eyes and think back, I can still remember the delicious aroma of flue-cured tobacco. As Mama once commented, there is an art to curing tobacco and it is not necessarily an easy one.

To cure tobacco, every barn was equipped with four gasoline burners and, at times, the heat inside a barn was well over one hundred degrees. A barn would usually take about a week to cure, and during that time, Daddy would have to keep a frequent check on the barn to ensure temperatures were where they needed to be. This meant he had to get out of bed during all hours of the night and make his way to the latched barn doors by the headlight of his pick-up truck. He was most concerned that the unattended barns would catch on fire from stray leaves that would sometimes fall from the sticks. I always worried about him when he went out at night and would try to stay awake until I heard the sound of his truck turning back into our driveway.

I will never forget the night the unthinkable happened, and we lost two full barns of tobacco at one time. Apparently, a leaf fell onto one of the burners when Daddy closed the door behind him, and because a long shelter connected the two barns, we lost both of them.

By the time Daddy returned home that night, we could see the fire from across the field, which was located between our home and the burning barns. I remember feeling scared as our family stood on the back stoop and watched the flames, all the while knowing there was nothing we could do. It was a devastating loss and, for me, it was devastating to know how much this loss hurt my mama and daddy.

Grading the Leaves

Immediately after the curing process and while the tobacco was still in the barn, the barn's dirt floor was wet down with barrels of water or sprayed down with a water hose. The doors of the barn were closed, so the moisture caused by the evaporation of the water would soften the leaves that were sometimes made brittle from the intense heat. Also, the moisture helped to prevent the stems from mildewing, which could ruin the whole barn. This process is called "coming into order" and, afterward, the tobacco is ready to be moved to the packinghouse for grading.

After the barning, stripping and selling season was over, packinghouses became the "catch-all" for tobacco sticks, surplus plows, leftover chemicals, et cetera. Sometimes even household furnishings that had become outdated and were in the way were stacked in out-of-the-way corners. Everything stayed there until someone made a decision about what should finally happen to it. Note the attached shed, which was used to hang dried tobacco until it was to be readied for market. *Picture courtesy of Sandra Broome.*

In early fall, Daddy would work at big Planters Warehouse on 301 South in Smithfield. With him working at the warehouse, Mama shouldered full responsibility for grading our tobacco so that it could be taken to the market for sale. To grade the leaves, she would first use a butcher knife or Daddy's pocketknife, make one cut to the twine in just the right place and quickly pull the bundles of cured tobacco from the stick. If you were not able to find that one particular thread of the cotton twine, removing the bundles was a tedious task, and while Mama showed me repeatedly, I never did acquire the knack of locating that one crucial thread.

After the bundles were removed from the stick, every leaf was separated and sorted according to appearance or condition of the leaf. The trashy, deteriorated leaves that had not cured out well were put in one pile, while the higher-quality, better-selling leaves were put into another pile.

Small bundles of leaves were then tied at the top with a folded leaf of tobacco and the bundles were placed back on the sticks. The sticks of sorted, tied tobacco were piled on the floor in the corner of the

packinghouse and flattened by laying a board over the pile and having someone stand on the board. Packing the tobacco down this way allowed us to make maximum use of space. Standing on the board was usually my job, and I thought it was great fun. I was obviously easily entertained at that young age.

I have heard Mama speak of the early days when she would sit in a hot packinghouse grading tobacco. I was a toddler at the time and would always be there in the barn close by her side. She would situate me on a pallet near the barn door in order to keep me as far away as possible from the thick, choking dust. Mama, who was only nineteen years old at the time, has told me that she would often cry because she felt a dusty packinghouse was not place for a young child. However, in her true fashion, she would try to make the best of a difficult situation and passed the time by telling me nursery rhymes and signing songs to me. This is just one example of the many times throughout her lifetime that she chose to take an optimistic outlook during difficult conditions. Her philosophy in life has always been that while you may not be able to control what is going on around you, you can control the way you choose to react.

AT THE END OF THE DAY

No one ever thought of leaving the barn or considered the workday to be over until Daddy acknowledged that we were stopping for the day. When it was time, he would always say, "Let's go to the house." Those were some sweet-sounding words at the end of a long, hot day at the barn.

The Good Life

By Betty McLawhorn

"Tobacco culture" is more than just a romantic phrase; it is the product of collective influences instilled by having grown up within an environment of specific values. The elements of these values were directly tied to the self discipline imprinted into one's character from a life of hard work, of rigorous schedules, of learning how to deal with disappointments, how to appreciate the fruits of labor, how to work together with family and friends toward a common goal, how to share in a comfortable livelihood and, most of all, how to see the hand of God in it all. In Betty McLawhorn's "The Good Life" there is included a bit of all these things.

Mechanization has almost completely changed the tobacco industry since my childhood, and since I have seen no written accounts of its infancy in our area, I think it is time to record for posterity the changes as I remember them.

My father was a tenant farmer—and a very good one. We didn't call ourselves "sharecroppers." That term I never heard until I was in school, and it applied to Civil War stories relating to ex-slaves. We were not a great deal different from many families around us who had undergone reversals during the Depression years, though most of our neighbors did own their small farms and perhaps fared better than we, though I didn't know it. Nevertheless, our farming methods were much the same.

Tobacco beds were the initial endeavor. These beds were always placed in an area protected from wind and weather, close by the woods and not in the middle of the choice land later used for planting. Sometimes "new ground" was so utilized, this being an area cleared of timber and stumps during off-seasons. Timber was necessarily cut for firewood in our homes, as well as for the tobacco curing process. Of course, I was not involved in any of that activity, but I can remember feeling that it was risky business and required long, hard hours of work with two-man cross-cut saws, axes and mules and wagons.

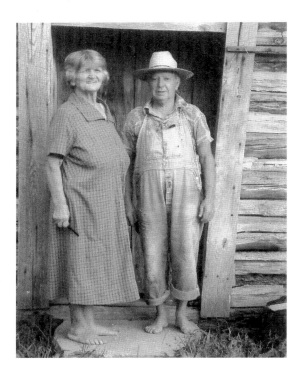

Part of the farm scene then were huge piles of logs at the tobacco barns, and the ever-present woodpile in the backyard, usually consisting of sections of trees approximately a foot long. Lucky were the people who had their stove wood cut and stacked for the kitchen stove ahead of time. Remember trying to start the fires with green wood? There were few newspapers in that period of time (we felt very privileged when we could finally afford a subscription) so we had to resort to using a little kerosene from the can usually kept for lubricating saws and other tools. (Sometimes it also served as furniture polish.)

May I add here, all of our family learned to wield an axe when we needed splinters to start a new fire. Standard equipment was the ever-present lightwood stump at the edge of the woodpile. Cutting stove wood for emergencies was not too difficult for us young ones if our woodcutters had previously split the firewood stumps with the use of a metal splitting tool.

Back to the tobacco bed: this small area was cut and plowed with various mule-drawn implements until it was devoid of the slightest lump of earth or stable manure. Tobacco seeds carefully saved from the best hills of tobacco grown in the previous season were then hand sown, later

to be meticulously tamped down with the back of a hand-operated hoe. At this point vegetable seeds, also saved from previous plantings, were sown along the edges of the plant beds.

About every other year it was necessary to replace the tobacco cloth used as a protective cover, an essential measure since unstable elements or windy weather might easily prove disastrous to the plant growth. Snow on the beds was not unheard of. The tobacco cloth used for this procedure came in bolts about a yard wide and perhaps fifty feet long. It was the duty of the womenfolk to sew the cloth together. This was done with big needles and lengths of tobacco twine. I can remember being conscripted to holding the edges together while Mama whipped the twine over and over in stitches about an inch apart. As she finished a portion of stitching, she then carefully plaited by hand huge sections of the cloth until it was time to add another width of the cheesecloth. Later she learned to sew the sections together on our precious sewing machine—foot-pedal model, of course.

When the cover was finally all in one piece, it was taken to the field to be placed over the planted bed, where supple twigs and branches were waiting to be pressed into the earth at intervals and in small semicircles, to hold the cloth up so the plants had room to grow. After the cloth was painstakingly put into place, "stobs" were placed around the perimeter of the planted area and driven through the edges of the cloth into the ground. Watering never seemed to be of prime concern in those days. Quite the contrary; part of the original preparation consisted of elevating the surface of the fertile area to allow for drainage. Sometimes a small trench encircled the covered plant bed for surface drainage.

After days and weeks of solicitous observation, minute plants seemed suddenly to explode beneath the canopy, and weather permitting, plant bed covers were now gently removed, plaited together to store overhead in the packinghouse rafters for future use, and so began the hardening-off process of the plants. As they grew, so did weeds. These weeds had to be removed by hand and by gentle extraction, lest tobacco plants be injured. Meanwhile, land was disked, plowed, laid by and furrowed (I'm not sure in what order) with the aid of our faithful friends, the family mules. Whether other farmers valued their mules as we did is questionable, because we often commiserated over the bony, underfed animals we sometimes noticed being beaten in the fields. Not so ours. We were proud of our sleek, well-cared-for animals. Daddy spent lots of time grooming our mules with metal currycombs, trimming their manes and toenails. I shall never forget watching him with hammer and chisel working on their hooves, all the

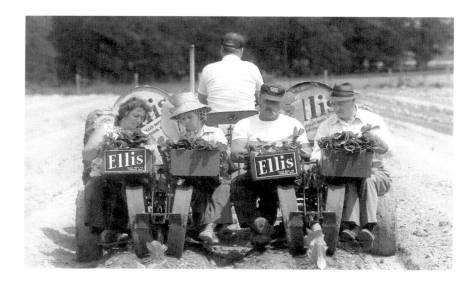

while talking to them to allay their trepidation. Sometimes we held the reins while he worked, patting soft noses or swapping curious stares.

One of my most vivid childhood recollections is the memory of complete peace and happiness at the sound of Daddy's voice in the quiet of the mornings at sunrise when he went out to hitch up the plow. He sang so beautifully, and the sound was like no other sound I've ever heard.

With the advent of a riding plow, or other two-horse vehicles subsequently used, I remember hearing my father express sympathy for the poor animals and their added burdens; so much for "progress."

Replanting or "setting" tobacco, as it was called, was done with a riding cultivator. The job of driving this apparatus was of primary importance because the mules must be kept moving slowly, steadily and directly between the rows. The driver's seat poised above a cylinder in which water was carried—filled from the well, and at regular intervals. Two of the most meticulous workers were chosen to sit in the suspended seats close to the ground behind the water vessel. On their laps were held enough tobacco plants to set out a complete row—always in symmetrical order and treated with infinite gentleness. At the click of the water-release valve, a single plant was dropped into a small hole made by the planter, and subsequently the root was covered in a squirt of water. The women of the household were simultaneously pulling plants from the plant bed, careful to minimize injury to surrounding areas where they usually sat down on small boards or tow bags fashioned for this purpose. Transporting plants from the plant bed to

the field by way of tobacco trucks was usually the job of the teenage boys. Those of us who were too young to do other work carried drinking water to the hands. For this we used fruit jars with metal lids. Incidentally, all of us knew how to start the pump if need be; sometimes we had to prime the pump with a dipperful of water until the water flow was resumed.

Those of us not pressed into some other service were expected to look after the younger ones. I don't remember feeling any hardships with such a task because there were always things to do, toys to play with, trees to climb. Our trees always had swings and our imaginations never failed to provide adequate entertainment. If you never rode the range on a tobacco-stick horse, then you are deprived. Pity the poor youngster who never used a plow-line jump-rope or sailed from a tree on a vine like Tarzan. One of our favorite playing spots was under the house among the doodlebugs, where we built villages filled with houses and roads made by wooden-block bulldozers. When there were enough people big enough to play, we had ballgames. Three-hand knock was good for hours, even if we had to use a broken tobacco stick and a tin can.

Mealtime was always a joyous occasion. We must have had elves at work, because there were always big pots of vegetables, meat from the smokehouse, pies during fruit seasons, hot biscuits and/or cornbread and, if the iceman had come that day, gallons of iced tea. But that is another story.

After stuffing ourselves, those who had to return to the field usually stretched out on the porches to rest until the bell rang. I assume everyone had a big bell standing on a scaffold as we did. During spring and summer months that bell was our nemesis. We were not allowed to play with it at all because it was strictly for emergencies such as fire, illness or injury. Fortunately for us that never materialized.

After setting out the tobacco we had no urge to celebrate because, from that point in time until summer's end, there was no respite. Immediately after setting the entire crop, nearly everyone joined in the resetting process. We would carry plants in buckets and replace sickly plants or fill in places where there were voids. In those days each plant was destined to be a masterpiece and was placed about a yard away from its neighbor.

Resetting pegs were works of art. Made from lightwood sections, they were about eight inches long, carved to a fine point on the end and smoothly fitted the hand. When jabbed into the earth they would make a perfect receptacle for the root and stem of the tobacco plant and a fine tool for packing the earth over the root. This was only one example of Daddy's expertise with his pocketknife.

The plants we were putting in the ground had to be watered individually and I remember avoiding that job when possible.

Next came the chopping, plowing and worming. Meanwhile the rains fell and the plants grew—and along with the growth came the inevitable tops and suckers. In my opinion there are few jobs in the world quite like suckering tobacco and I think I can forever do without it. I am not the least surprised that some enterprising individual learned to use a chemical for dispensing with tobacco suckers, bless him! What is a sucker? It is a small cluster of leaves in its own little package that grows in the spaces between tobacco leaves and the stalk. Left alone, it saps the vitality from the tobacco leaf and thus must be removed. The tops also had to be lopped off for the same reason. It was the mark of a slovenly farmer to see his tobacco field in flowered tops after a certain point of growth. Of course there were always choice plants left to blossom for seeding purposes.

Everyone was housing tobacco at least by July 4. Celebrations were things we only read about. I once heard an elderly lady of my acquaintance say that she prayed she wouldn't die during tobacco housing time, because she'd surely be left lying there until the crop was in. She may have been right. To the uninitiated, putting in tobacco would be an incredible experience.

Since I describe a time before mass production became fashionable, each leaf was valuable. The ultimate aim was for golden "wrappers" rather than volume. From beginning to end we were taught to handle our tobacco crop with care.

Priming was the first exercise in perfection. Only the ripe leaves were picked, and bottom primings, or lugs, presented a challenge to endurance and a strong back; a job only a few hardy souls dared attempt. A mule-driven vehicle, or tobacco truck, was wheeled down the rows as primers picked leaves, tucked them under their arms and placed them into the truck when they could hold no more. It was important that they place them stem-end out for the convenience of the handers.

The tobacco trucks were encircled with fertilizer bags, which had been opened and then stitched together and fastened to the four upright rods placed in holes on the four corners of the vehicles. Nails held the burlap corners in place until handers removed them in order to hand the leaves. In later days, wooden frames helped to support the bags on the sides, thus creating a receptacle resembling a crude baby crib. The wheels were metal-rimmed wooden ones and needed frequent lubrication.

The trucker's job was considered one of the more desirable tasks, although this also entailed considerable expertise. It was his responsibility to catch the mules, hitch them to the trucks and take care of their maintenance. It must have been rather monotonous going to the shelter and back to the field over and over, but driving the mule and being mobile helped a little. The paths they traveled were always full of deep ruts and were especially troublesome in the wet weather. Many truckloads of tobacco overturned in transit, creating minor tragedy for the truckers and handers and, indirectly, to the whole crew in lost time and aggravation.

As the trucker carried the tobacco trucks to the shelter, he maneuvered into proper position, unhitched the singletree from the full truck, connected it to the empty one with mule in tow and then he returned to the field where he exchanged mule and cart for one that had been filled in the interim.

We have followed the primers and the trucker with truckloads of plucked leaves, arranged, hopefully, in orderly armloads with stems faced to the outside for the most part, and now it was the job of the handers and loopers to execute their parts of the operation. The shelter crew collaborated in the task of pulling the empty truck from under the shelter and then pulling the loaded truck into position between two parallel sawhorses—half-triangular structures built to hold a tobacco stick horizontally, fitted into ends with V-notches on top of them and about waist high for the loopers.

These loopers, usually ladies most talented in the art of wrapping tobacco twine around the heads of the leaves in such a way that they held securely, first stationed a knot on the end of the stick facing them and then proceeded to loop, a bunch at a time, on alternate sides of the stick until the stick was filled to the other end. There, the string was, again, tied in a knot and broken in two.

Meanwhile, handers, usually two at the side of the truck, lowered the burlap sides and formed bunches of three or four leaves at a time, which they

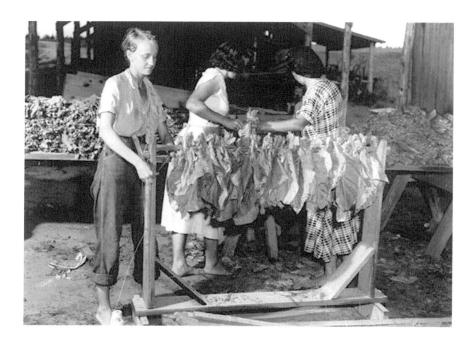

then handed to the looper one bunch at a time. An adept hander picked up the leaves with one hand while offering bunches to the looper with the other. As the stick was filled, one hander took off the stick and carried it to the rack or pile, while the other hander picked up any leaves that had been dropped. And so went the activity from early morning until sundown.

In the heat of the process of integration I often thought about those summers spent in housing our tobacco crops, for it was then that I learned how trivial all those arguments really were. We worked together, blacks and whites, never thinking about class consciousness or inferiority. I am still fond of those people and remember their many kindnesses with gratitude. I do not recall anything but harmony.

We sang together, swapped stories, teased one another—anything that helped us to get through the days. The best workers were respected, and knew it. When we'd finished the required number of sticks for filling the barn at the day's end, it was always good to see the primers come in from the field and prepare to climb the tier poles for the final task of "poking up" and filling the barn. Most of the time we had stationary racks beside the barns onto which we had placed the sticks of tobacco, and we formed an assembly line and handed the sticks to someone inside the tobacco barn, who in turn handed it over his head to the man on the lower tier of the

upper racks, who in turn handed it up to the man on the higher level. Bear in mind, after a day in the field, these gentlemen straddled the poles and hung the leaf-laden sticks onto the racks up in the barns, not too close but not too far apart, ever cognizant of the need for heat circulation. Most of the time there was an air of jubilation that the day was ending and rest was imminent. Oftentimes jokes were forthcoming about the day's events, never meant to wound or debase anyone.

Sometimes there would be lulls in the day's activity, especially during harvesting of lugs or when the primers found the heat devitalizing. While some of us sat down to rest or perhaps to nod a little, others chose to raid fruit trees or bring a watermelon to share. I wonder how I would feel if I saw one of my grandchildren eating from hands covered with sticky and black tobacco gum. Well, it wasn't too bad.

Once a black friend told me that she often cooked tobacco worms and found them delicious. To this day I don't know whether she was putting me on because she sounded completely sincere. I doubt they'd be any worse than snakes and snails, but I hope I never get so hungry. In this day of insecticides and chemical use, I doubt many of today's generation would recognize a tobacco worm if they saw it, which is certainly no loss to anyone because they were gruesome creatures, sometimes bigger than my thumb. They seemed to be more prolific as the season progressed.

As each barn of tobacco became filled, and a thermometer was hung on the lowest tier, then it was "fired up." Curing tobacco with wood is now obsolete, and happily so in view of the present need for conservation of our woodlands, but it was really an interesting procedure. While I am not very knowledgeable about the art of curing, I can remember hearing about it, and I'll never forget the sensations it aroused. There was a certain aroma about the process of "cooking" green tobacco and drying it to perfection that only those of you who were there can identify. Mingled with wood smoke, it was always a pleasant experience for those of us noncurers. For the curers it was a week-long endurance test; success or failure was determined by the finished product—the quality of the leaf after it was properly cured made all the difference in the price it would bring at the tobacco auction.

At this point in time buyers were especially interested in a quality leaf—one that had been cured to a golden yellow with a slightly leathery consistency. To achieve this model of perfection each stage of curing must be expertly timed and correctly fired. Initial firing was done with only a minimum amount of fire in the furnace until the drying began, and then slowly increased in volume until the last hours when roaring

fires presented very risky vigilance around the clock for a given number of hours. How in the world our menfolk were able to survive the grueling hours is a mystery to me, for they usually worked in the fields by day, then oftentimes stayed awake most of the night to watch the fires and the temperatures in the tobacco barns.

Once in a while we youngsters were "privileged" to stay in the barns with Daddy, where we slept on tobacco trucks—in spite of the mosquitoes. Close to the burning furnaces they weren't so bad. We used to try to roast corn or potatoes in the embers, but never had much success since at that time tinfoil was unheard of.

When a barn of tobacco was finally cured to perfection—after about a week's time—it was necessary for us to crawl out of bed before daylight in order to help "take-out." We usually handled two sticks at a time, in another assembly line, to move it from the tier poles to a horse-drawn wagon; then we handed it up into the packinghouse where it was carefully piled to await the grading process. Our packinghouse was located over the mule stable; thus, we had to improvise ways to pass it overhead into the open upstairs door. During the process of taking out the cured product, we were taught to call attention to any sticks on which the stalks had not completely dried out, because moisture left there would create heat and subsequent mold in the tobacco piles. These sticks, called "swell stems," were put aside to be left outside until dry.

By the time we had finished moving the dry tobacco, it was time again to start another day's housing chore. Needless to say, we never had to be coaxed to go to bed at night. Woe unto us, however, if we failed to take baths first. We were often tempted, though it wasn't such a big problem to pump a big sink full of cold water, which we put our feet in. We usually used lye soap that Mama had made. Not knowing better at the time, I don't remember feeling deprived. We were clean. Often we were told: "Cleanliness is next to Godliness."

Rainy days offered no respite, for the crop had to be taken care of rain or shine. I remember an occasional altercation when some zealous shelter hand splattered someone in the face by flipping tobacco leaves. Most of us tied guano bags around our waists for protection, held together in the back with nails. Those were long, long days.

Finally it was over. The top leaves on the stalks, the "tips," were small and aggravating to handle, but we never minded too much because we were so happy to see the end of the season. As we finished pulling and barning the last of it, we usually celebrated by eating watermelons, or if

we were lucky enough to afford them, several crates of soft drinks—in those days a rare and wonderful treat.

At this point in time we were privileged to enjoy a few days' respite before the opening days of school—our "vacation." Generally our vacation consisted of a few days' visit with relatives, if we were lucky. Meanwhile, my mother was busy sewing our clothing for the upcoming season and Daddy was busy harvesting corn, hay and other crops that he had been tending in addition to the tobacco crop.

Do you remember sweet potato mounds? A shallow pit was filled with sweet potatoes, covered with straw and stable manure for the heat it was to generate and then covered with dirt to form a veritable igloo. Thus we were able to enjoy potatoes until far into cold weather months. Irish potatoes were generally spread into layers wherever there was space, either inside or under a building—sometimes under the house. Insect infestation wasn't the problem it grew to be in later years, but the last of the supply was invariably full of sprouts, which sprang from the potato "eyes."

Our pantry and spare room in the house were always filled with glass jars full of canned fruit and vegetables (evidence of yet more chores) that had to be taken care of during tobacco season. Our spring gardens were always works of art and were plowed once a week at the end of day's plowing in the field. Farm gardens were always a source of pride as well as sustenance. Even the poorest among us always had a few rows of collards as well as cabbages and turnips. There was always enough to share.

Hog killing in the fall was also a way of life. Gone are the artisans who knew the fine art of killing, cleaning, cutting and curing for the smokehouse. It was excruciating labor form beginning to end, but essential to our livelihood as we knew it. We depended on the byproducts such as lard and side meat for seasoning everything we ate, which was done with a heavy hand.

As the corn crop was harvested entirely by hand and conveyed by mules and wagons to the storage barns, some of the choicest dried ears were carried in fertilizer bags, usually, to the local gristmills where they were ground into cornmeal—another accepted necessity.

Each of these various activities is worthy of more complete description, but I mention them briefly only to call attention to the multitude of activities that took place in addition to the hectic pace maintained during the tobacco harvest season.

Nearly everyone I knew in those days was one of a big family—obviously an economic necessity. There were no slaves, nor was there money for hired labor. As I grew older I became aware of more prosperous families

"We live on hogs and tobacco around here."

whose farms consisted of numerous small houses, which provided homes for indigent families in exchange for their labor.

While it is true that this was akin to slavery, these people—most often black people—were free to move at will, which they did very often and very often with justification, but those who were energetic were rewarded in many ways. I heard stories about miserly and cruel landlords, but I never knew them.

My most cherished playmate as a child was Bert Robinson, a black child who had been adopted by Lizzie and Mac Robinson, who lived near us and worked together with my parents. While Lizzie and Mama graded tobacco, Bert and I played together. She taught me to do the "snake-hip" and "ham-bone." I probably introduced her to smoking rabbit tobacco. Lizzie was my surrogate "mother" until we moved away to another area and I finally lost touch with them, but I remember only a happy association.

"Grading" tobacco is another lost art, though I doubt it is missed very much. As I said earlier, our tobacco crop was handled leaf by leaf with an eye to the perfect "wrapper." In our grading room, the focal point of the whole operation was the grading bench, which was built in a semicircle closest to the best source of light, and at intervals of about twelve inches there were drilled holes into which were placed slender sticks from the floor to about twenty inches above the surface. The grader sat in the center of the circular bench and distributed each leaf according to its

color and texture. Sometimes there were a dozen different grades; the sale price very often reflected the expertise of this operation.

As children we were expected to help move the sticks of tobacco from the packinghouse to the grading room, and to help pull it off the sticks using a sawhorse, which we'd also used in housing the "green" tobacco. To pull off, we first broke the string on the end of the stick and then proceeded to pull off each small bunch, from alternate sides of the stick, and stacked them within reach of the grader. We were reprimanded if we were not very careful and if we failed to keep the discarded strings in neat piles. Emptied sticks were placed together horizontally in a corner, to be later removed to the tobacco barn shelter for next year's harvest. Incidentally, these tobacco sticks had been painstakingly made, sometimes by hand, from very straight trees and to specific dimensions. I guess they lasted a lifetime and were carefully guarded. The "grading" stocks were carefully planed smooth for the perfection of the final product. These were even more valuable than the sticks.

After the grading process came the tying. We were taught to smooth out a choice, pliable leaf across our knee, fold it about a third over, start from the tail of the leaf and then form a neat, covered wrapping of the stems of the leaves that we had made into a small, symmetrical bunch in our other hand. My parents taught us to make the finished bunch very smooth and neat and as uniformly exact in dimension as possible.

After grading and tying all the tobacco we had moved to the grading area came the process of "stringing up" the bunches. Using smoothed sticks, the bunches were separated in half underneath the head and balanced end to end on the sticks until they left only enough of the stick

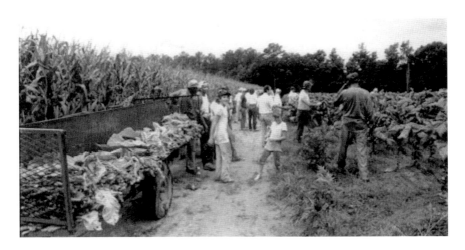

on each end for handling. Then, very carefully, they were stacked in a pile in the corner, each stick meticulously smoothed and pressed with a twelve-inch board of equal length to the stick. Each grade was kept separately, sometimes marked by the use of a string.

We children were rarely allowed to help in this process, since we probably weren't careful enough. I remember the cozy feeling of family "togetherness" associated with the tobacco grading. Perhaps by this time we anticipated the end of the harvest, as well as the prospective sales. It was at that time that all of us learned to harmonize as we sang together. My parents sang a lot. We sang old hymns as well as the current songs we heard on our battery-powered radio.

Electricity was not used in the country at that time. A few wealthier families used carbide light, but we used kerosene lamps and lanterns and felt rather privileged to have them instead of candles, although I couldn't remember being without lamps. All of us helped in their maintenance. When we refilled them with kerosene, we were expected to clean the lamp globes as well as the wicks.

I finished high school by lamplight and never felt deprived; I knew none other. We were expected to be good students and we were. We always read a lot and frequently visited any available library. By some means, which I can't remember, we had access to current magazines and newspapers, which we read avidly.

My Daddy hauled his tobacco crop to the warehouses in Greenville with mules and a wagon, as everyone did I assume. I knew very little about the sales because I was grown before I saw the inside of a warehouse. I do remember the pride we experienced when our efforts were rewarded by good prices—sometimes three or four cents a pound.

In those days we were not restricted to limited acres or poundage by law, but by the number of acres left after essential food-crop acres had been designated. Each farm constituted family livelihood. It was after Daddy died in 1936 and we left the farm that the mechanization began, thus ending the agricultural industry as we knew it. I do not mourn for those "good ole days," but I do feel nostalgia for the simplicity of the life we lived. Then, as today, there was good and there was bad. Change is inevitable in the scheme of life and I look forward to being its happy witness for yet another plateau in the evolution of the farming community. It is still "the good life."

Reprinted with permission.
Housing Tobacco, 1929

Mary Sharon Thompson:

A Lifetime of Memories

Mary Sharon Thompson is a very deserving award-winning poet and prose writer. With a wonderful talent she has passionately captured and expressed the thoughts and feelings that fill the hearts of those who have endured life on a tobacco farm. Her works weave a warm and vivid re-creation of a lifetime of memories growing up on a North Carolina tobacco farm. She is one of the most creative and perceptive writers I know.

PLANTING TIME

We drove down into the woods dodging the limbs that had crept into the winding path. It was time to pull tobacco plants from the beds and transplant them into the field. It was always early in the morning—early and wet for the morning dew clung heavily to everything.

The chore wasn't that awful, but I was not extremely productive as I spent more of my time checking for snakes than pulling plants! It was necessary to know exactly which plants were the proper ones to get. Equally important was knowing how to pack them into the basket. The basket had to be laid on its side and packed as tightly as possible, but at the same time one had to be careful not to break or bruise a plant. My brother and I would load the filled baskets onto the truck or trailer, and I remember how the worn handle on the basket would dig into my small hands and leave red indentions that hurt. Whenever possible, I would volunteer for the job back at the field.

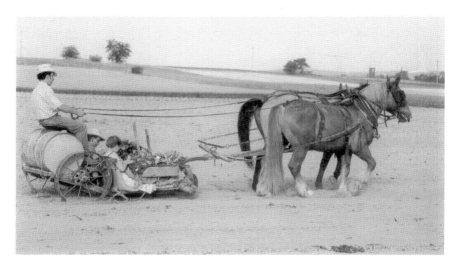

Horse-drawn tobacco planters are one step ahead of hand planters. You have really arrived when you can afford this type of technology. *Picture courtesy of Pam Barefoot, "Mules and Memories."*

I recall standing at the end of the freshly ridged row with my arms full of tobacco plants. Those rows were so long! I always detested it when Daddy ridged them the length of the field. The short rows were so much easier! (My child's mind never realized that the same amount of work was there, no matter how the field was ridged!)

For years, I never knew there was such a thing as a transplanter that was pulled behind a tractor—one that swallowed plants and placed them into the row in perfect unison. But, of course, we still had mules at that time, not a tractor. The only transplanter I was acquainted with was one of those rusty, old things with jaws. This entailed quite a number of chores. First, there was a barrel to be filled with water from which bucketfuls were dipped. My brother's job was to keep the buckets of water handy for the transplanter. My duty was dropping the plants for Daddy. And Daddy, his job was handling the transplanter and yelling at us because we could never seem to synchronize our jobs to his satisfaction! The plants and water never seemed to work out evenly and patience was not one of his virtues, especially during this time of year. But we always managed to get through those long rows that turned into acres. I can't forget the smell of the young green tobacco plants, the gritty dirt on my arms and the water sloshing on my feet whenever Daddy burrowed the planter into the dirt.

Later, we progressed to a more modern way of impregnating the earth with those tender young plants. Planting time was just the beginning. We were creating a multitude of work for ourselves in the days ahead.

I never imagined we were creating a picture that would one day be on a page in my book of memories of growing up on the farm.

GOLDEN DREAMS

With crooked back and sluggish feet, the old man made his way down the path. His Red Camel overalls and faded, plaid shirt were the only splash of color against the gray barn. Frayed edges from his straw hat hid his wrinkled skin and blue eyes from the late October sun. Reaching for the brush beside the path, he pulled a straw and stuck it between his teeth. He took this same walk each afternoon, but today required more strength than usual. The thick sand under the barn shelter was inviting to his aching bones. Sighing heavily, he stopped to rest.

Someone had dropped a tobacco leaf in the sand. He reached for it, thinking, "Now this here's a good leaf...too good to be wasted." It was cured golden and supple with dark, glossy veins running through it. Still holding the leaf, he pulled his hat over his eyes and leaned his head against the barn door. The aroma of mortar and logs, along with curing tobacco, engulfed him and he drifted off to sleep.

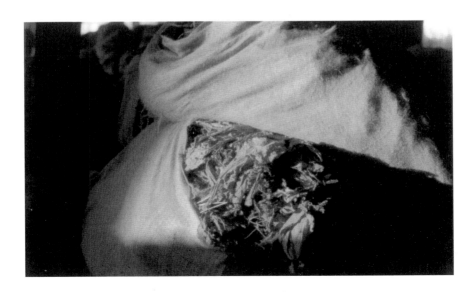

He dreamed of golden leaves and golden times. His dream recalled spending an entire day with his mule in one tobacco field. He saw nights when he walked by lantern light to check the fire in his curing barn. Sometimes he would sleep by this same barn door all night. He heard his wife ringing the rusty, old dinner bell to call him from the field. The children were hanging onto her apron with dirty hands. His dream included neighboring farmers dropping by on Sunday afternoons. They walked through the rows of crops to see how they were "coming along."

Those days were long and tiring, happy and rewarding. Hard labor and trying times produced his crop. Those same things held his farm and family together. He was proud of his life. It held all the things close to his heart.

The sun now turned from golden yellow to blazing orange as it sank behind skeleton trees. As it slowly disappeared, cool darkness surrounded the old man. He still lay against the door, the straw no longer between his teeth and a pleasant smile on his lips.

Somewhere in the background, the old dinner bell was ringing, calling him home. His cold hands clutched the leaf and he slept, dreaming his golden dreams.

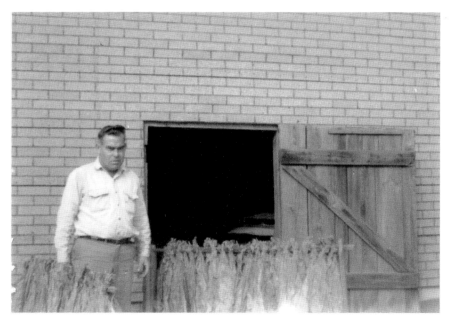

William "Curley" Thompson, tobacco farmer and noted country/bluegrass singer from Four Oaks, North Carolina, stands in front of his barn, proudly showing off a stick of fine quality tobacco, circa 1960.

PATCHES OF THE PAST

In the chill of autumn's afternoon
Under a quilt of multicolored cotton
I snuggled, warm in the memories
Of childhood days almost forgotten.

As I ran my fingers over each design
I felt other hands had been there,
Hands of some younger women,
Hands of those with gray-white hair.

Their stitches flowed in harmony
Over a medley of collected scraps,
But pangs of age and arthritis
Left some hands folded in their laps.

Those scraps came from many places:
Feed sacks, curtains, old dresses of mine.
Amazing! How tidbits of cloth
Became a lovely kaleidoscopic design.

The beauty in old country quilts
Isn't in shapes of a star or a heart,
But in fellowship—the patience and time
Of neighbors creating an art.

Clothes that my brothers and I outgrew
Are now patchwork bringing a smile.
They blanket me, patches of the past.
I'll just snuggle here for a while.

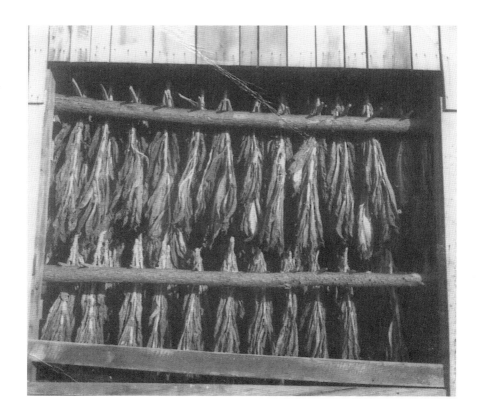

GITTIN' OUT TOBACCO

It's 4:00 a.m. and still quite dark.
Daddy yells, "It's time to get up!"
I smell hot coffee on the stove,
But there's no time to pour a cup.

I'm sure I have just gone to sleep,
Must have been just a minute ago!
But my stiffened body rolls out of bed
And, slowly, the blood begins to flow.

It's time to empty the tobacco barn
Just so it can be filled again.
There's so much to do before daybreak,
Then a day's work will still remain.

It's summer, but the air is cool.
The grass is wet with morning dew.
Inside the barn, it's dark and warm,
So I snuggle to the nearest flue.

I take the sticks from my brother
Who's hanging above on a tier.
He shakes dirt on me, and I scream—
Daddy pretends he doesn't hear.

We head for the pack-house to unload,
And I'm really in a nasty mood.
Daddy says, "Stack it straight, now,"
But all I can think of is food.

Mama finally yells, "It's breakfast!"
As our rooster crows at first light.
Smelling country ham on the stove
Gives me a hearty appetite.

I wash the dirt off my neck,
Put grits and red-eye on my plate,
And just as I taste my eggs,
Daddy mumbles, "Well, my help's late!"

So after homemade biscuits and jelly
I throw an apron across my arm,
Start down the path to the barn again—
It's just another day on the farm.

SLEEPIN' ON THE PORCH

Growing up in the country when I was a child
Meant mules and drawing water from a well,
Going barefoot with chickens in the yard,
And announcing meals with a dinner bell,

Lye soap in a wash-pot and barning tobacco,
Dodging roots after dark by lantern light.
It meant hard work, but we had some fun—
Like sleeping on the porch on a summer night.

After a hard day's work and a foot tub bath,
We'd bring out quilts and pick our spot,
'Cause out on the porch was a little breeze,
Couldn't sleep in the house—it was too hot.

The old porch slanted and the uneven boards
Stuck in our ribs unless we lay just right.
The mosquitoes were hungry and Mama would yell,
"You're comin' in the house if you don't be quiet!"

Once the giggling and ghost stories stopped,
We could hear crickets, tree frogs and owls,
Leaves rustling softly in the night breeze,
A barking dog and lowing cows.

A full moon painted the woods black,
But lit up tobacco leaves in the field.
Finally as midnight rolled around,
We slept and night was magically still.

OLD BARNS

Looking as if just painted
On the cover of a magazine,
The old, forgotten tobacco barn
Is a lonely, nostalgic scene.

An air-conditioned tractor drives by
Gray boards and rusty, flapping tin.
It's a true picture of country life
Where the past and present blend.

One by one, they begin to vanish,
Settling and sinking in the ground.
Trees and brush hide them from view.
Vines embrace them as they fall down.

They're subjects of a tourist's photograph
And havens for baby birds in their nest.
We move on as they slowly slip away
As architectural history laid to rest.

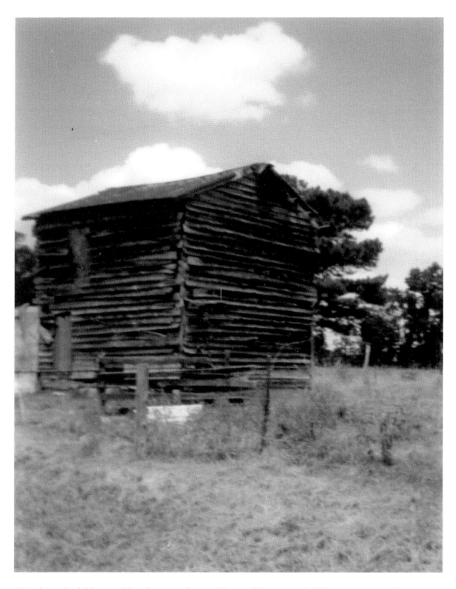

Weathered old barns like this one hosted lots of hard work. They also hosted a critical site wherein tobacco culture was woven. "If these walls [in this old barn] could talk," one might say, "they could write volumes of gossip, cold remedies, recipes, or any other learned revelations, heard through the endless bantering back and forth among the 'women-folk' as they busied themselves from sun-up to quitting time, handing and stringing leaves at barns." Even though the "barning" season was never more than six or eight weeks, many bonds of kinship were formed here between those who were brought together, and stayed together, from beginning to end. *Picture courtesy of Sandra Broome.*

A Nostalgic Moment in the Country

In the gray dusk of day, the old tobacco barn was outlined against a misty, rainy sky. There was a loose piece of rusty tin dangling from the roof that made eerie sounds each time the wind passed by. I turned an old bucket upside down for a seat, leaned against one of the posts holding the shelter up and the memories came flooding back. The quiet was so intense, so lonely, much unlike the days gone by.

I recalled steamy, summer afternoons when the aroma of green tobacco leaves drifted about and gummy tar was stuck to everyone's hands. Children who were too young to work, and that was really young, ran and played. Women shared recipes and a little friendly gossip, only to be interrupted when the men returned to the barn from the sultry heat in the field. Neighbors helped neighbors, "swapping" work for work in an era when a helping hand was as close as the next house down the road. The work was hot, dirty and strenuous. The days were long, but so were the friendships that were built on common interests and common goals of farm families.

I slipped my shoes off and sifted the velvety sand through my toes. Opening the barn door, I breathed in that familiar smell of mortar and mustiness. For a moment, I even thought I caught a whiff of cured tobacco.

I closed the barn door and, with shoes in hand, wandered away, feeling deeply nostalgic. The old barn seemed deathly quiet and lonely.

So many memories and so many changes—from logs and mortar to block and brick, the barns are now made of metal. We have gone from the horsefly being swished by a mule's tail to the air-conditioned tractor and numerous mechanical wonders. It is more often strangers tending the tobacco crop than our friends and neighbors. The time has gone when each leaf was handled individually and treated as precious as gold. The priority now seems to be mass production, and those lonely, scattered leaves remain wherever they may fall.

But those of us lucky enough to have known life on a tobacco farm will always have the memories—friends, neighbors and fellowship, the smells and sounds, and the tired, aching bodies at night. We will always have the satisfaction of knowing we grew up close to our fellow man and close to God's green earth.

Poetry and prose reprinted with permission.

"Gone are the days when my heart was young and gay. Gone are the days when, as a child, I romped in fantasy and play. Gone are the days when I lay my head on my mother's lap and my pain in her lap. Gone are the days… gone are the days."